MIGRATIONS

Edited by Lizzie Carey-Thomas

With contributions by John Akomfrah, Tim Batchelor, Sonia Boyce, Emma Chambers, T.J. Demos, Kodwo Eshun, Leyla Fakhr, Paul Goodwin, Nigel Goose, Karen Hearn, David Medalla, Lena Mohamed, Panikos Panayi and Wolfgang Tillmans

MIGRATIONS
Journeys
into
British
Art

TATE PUBLISHING

Foreword

On arriving as the new Director at Tate Britain I proposed looking at the collection in relation to its troubling name. The national collection of British art is frequently not actually British and yet is happily, even unthinkingly, accommodated within our galleries. This fact is especially striking for the earlier part of the collection, where most of our paintings are by artists who came from overseas. The simple premise, then, of this alternative view of the collection is that the national collection of British art is often called British simply by custom or convention. Some of these artists made their homes here, while others left, and yet their work is 'British', as it were, by adoption. Making art British, or making British art, are divergent avenues which often intersect.

I was interested in the way an issue that is seen as especially topical – immigration – has of course a much longer history, and the way in which that history maps very neatly onto what we show here. The different kinds of migration – with which we have become familiar through today's controversies and can be characterised, most simply, as the economic migrant and the political or religious refugee – are central to the stories behind the works on show. This particular cross-section of the collection has much wider ramifications, which reverberate with many other works elsewhere in our galleries and in our stores, as well as with the story of this island and its historic geographies. Our 'British' collection is un-British, just as Britain is more than British.

Migration is often discussed in binary terms, and the model of the 'melting pot' is contrasted with 'cultural diversity'. The selection here might be seen to do something of the same, moving as it does from artists who bring new 'goods', but seek to assimilate them into the mainstream, to artists who insist instead upon their difference and upon retaining the specificity of their 'local' inheritance. There is a story here of language or languages, in which a lingua franca (be it Latin, French or neoclassicism, jazz or abstract expressionism) is differentiated from a 'patois' or dialect. Perhaps the most interesting moments are those in which we see how an international language spoken with a regional accent can have a different meaning.

Alongside this overall theme we see a variety of period-specific inflections, in which new kinds of political or artistic institutions, transport links or economic imperatives cause certain countries to speak to one another in depth at certain times. The relationship with the colonies is played out in each direction, as artists seek training and patronage at home and abroad, and as opportunities are opened up with transatlantic transport. Key moments of repression – of Protestants in France or of Jews in Russia and Germany – are mirrored by

particular clusters of works in our collection, largely by artists who went on to make their homes here. The elasticity and durability of the notion of homeland is articulated in works that reflect two places at once, even (or perhaps especially) in a second generation. In this way, even if indirectly, a 'British' collection has come to reflect a much wider international stage.

I asked Lizzie Carey-Thomas to take on the potentially daunting task of looking at our collection through the prism of migration, and asked her to work with a number of curators with different period and country specialisms: Karen Hearn, Tim Batchelor, Emma Chambers, Leyla Fakhr and Paul Goodwin, who were supported by Lena Mohamed. In proposing the plural title the team has chosen to focus on different moments and on different aspects of migration, rather than suggesting any kind of definitive survey. Nevertheless, though each section has been overseen by an individual curator, perhaps the most stimulating aspect of their selection is the way in which it allows us to perceive parallels across time, and to see migration in terms of a longer history of art.

To look at the history of British art in terms of migration may seem obvious, but it is also challenging. I am grateful to the curators for their commitment to making this project work, and to Lizzie Carey-Thomas for her particular engagement. I should like to thank the various people – artists, critics and historians – who have supported them in their research, and Nigel Goose, Panikos Panayi and T.J. Demos for their written contributions. We are especially grateful to John Akomfrah, Sonia Boyce, Kodwo Eshun, David Medalla and Wolfgang Tillmans for contributing interviews to this book; their experiences, from very different periods and parts of the world, as artists who have become integral to British art, are testament to the underlying truth of the project.

Migration is a more elastic term than one might think, and especially so in the plural. In recent years we have been reminded of the more varied uses of 'migrate' as a verb relating to things as well as to people, to particles that change shape as they move from place to place. If we think of the way in which migration applies to birds we see it as cyclical, rather than final, and as something that repeats itself again and again. Although the selection here is, necessarily, resident in the Tate collection, and visible at Tate Britain, it has a mirror, as it were, elsewhere in the world. These artists have passed from one place to another, changing habitat periodically, and it is almost by happy accident that some of the fruits of their passage have come to rest here. A museum collection is a kind of final resting place for an artwork that may derive from a precarious and peripatetic life in the real world. This project seeks to remind us of that journey, of its points of departure as well as of arrival. Art may find its final home within the museum, but the journey that it represents continues to reverberate.

Penelope Curtis, Director, Tate Britain

Migration to Early Modern Britain Nigel Goose

It has been remarked that 'the British are clearly among the most ethnically composite of the Europeans'.[1] Britain might not compare with the United States in terms of the diversity of its racial mix, but this mix is a very rich one nonetheless, even if a longer history has served to render many earlier ethnic influences scarcely visible. It is too easy to forget that, '[wherever] homo sapiens made his first ... appearance, it was not in Britain: all our ancestral stocks came from elsewhere'; and many an ardent nationalist might be dismayed to discover that his or her early origins lie on the African continent.[2] Furthermore, despite their frequent appearance in early years' educational syllabuses, we also too often forget that the 'true-born Englishman' is in fact a product of an early admixture of Celts, Romans, Anglo-Saxons, Danes and Normans, which resulted from invasion, conquest or both. This fact was not lost on Daniel Defoe, whose 'satyr' with that very title – 'The True-Born Englishman' – was printed in 1700:

The western Angles all the rest subdued ... / The Scot, Pict, Britain, Roman, Dane submit, / And with the English-Saxon all unite: / And these the mixture have so close pursued, / The very name and memory's subdued: / No Roman now, no Britain does remain; / Wales strove to separate, but strove in vain: / The silent nations undistinguished fall, / And Englishman's the common name for all. / Fate jumbled them together, God knows how; / Whate're they were, they're True-Born English now.[3]

This is, however, only the start of a much longer story, for the ethnic mix that comprised the British nations at the start of the medieval period has been constantly refreshed ever since. Until recently it was continental Europe or, if we focus our attention on England, other parts of the British Isles, that provided most of this new blood. The list of incomers over the centuries is a long one, ranging from the French Jews, Italians, Germans, Netherlanders, Bohemians, Irish and gypsies of the medieval period, to the German, French, Walloon, Spanish and Italian immigrants of the sixteenth and seventeenth centuries, black Africans in the eighteenth century (estimates of their number range from ten thousand to over twenty thousand), the Scots and Irish, and Russian and Polish Jews in the nineteenth century, and West Indians, Indians and Pakistanis, and the recent wave of East European immigrants, between the post-Second World War years and the present day. This list is not, of course, by any means an exhaustive one.[4] Not all of these immigrants stayed long enough to exert a major, lasting influence upon the ethnic mix of British society. Not all were of great numerical significance. Indeed, before the sixteenth century there were very few sizeable and permanent immigrant communities outside of

London – the one great city of the land before the industrial revolution of the late seventeenth to nineteenth centuries transformed the urban landscape of Britain once and for all. The great majority of incomers in virtually all periods have been town dwellers, and the range of economic activities to be found in the capital and its extensive overseas connections have rendered it an obvious attraction to prospective settlers and temporary visitors alike.

Why has Britain proved so attractive to foreign immigrants? The reasons for their coming are diverse. Some early medieval communities were established by the monarchy for political reasons, others for their value as a source of finance. Britain has long proved culturally attractive, and again it has been London in particular that has exerted the most profound influence. Entrepreneurs in a wide variety of industries and from various countries have been encouraged to settle in Britain across the centuries by the grant of certain privileges, such as German miners and metal smelters in the sixteenth century, or the Dutch engineers in the seventeenth century whose expertise in land drainage proved so invaluable in the fenlands of East Anglia. Other entrepreneurs, particularly in the nineteenth century, came of their own accord to reap the benefits of England's early industrialisation compared to continental Europe. But those who have arrived in greatest numbers have generally had something to escape from: political or religious oppression, economic dislocation or simply the lack of economic opportunity relative to that perceived to be available in Britain.

It follows that there has been more than one kind of immigrant. A relatively small number have been of quite elevated social standing, including some political emigrés and others who have brought with them considerable liquid capital assets – such as the medieval Italian financiers, the Dutch and Jewish investors who contributed to English public finance in the early eighteenth century,[5] or the Russian investors in the London property market of recent years. More numerous have been the skilled workers – whether the Dutch and French cloth and silk weavers of the sixteenth and seventeenth centuries or the eastern European plumbers and builders of the early twenty-first. Others still have been unskilled and have gravitated towards jobs at the bottom end of the labour market – such as the nineteenth-century Irish labourers who made such an important contribution towards the building of our national rail network, or the West Indian men and women of the 'Windrush Generation', from 1948 and into the 1960s, who formed a significant pool of labour for both London transport and for the National Health Service. Of course not all waves of immigrants can be easily classified as falling into one or other of these groups, and some include representatives from all levels in the social scale. Nevertheless, these broad characterisations remain useful, and have certainly been used by both politicians and pundits when formulating political and social attitudes towards incomers to these shores.

Immigration has invoked a diverse range of responses too, and continues so to do. These can be exemplified by cases studies from across the centuries, but the one that is most familiar to the present writer is that of the Flemish and Walloon settlers who came to England in considerable numbers from the mid-sixteenth century, a considerable number of whom found their way to the town of Colchester.[6] Late in 1561 the Corporation of Colchester agreed that Benjamin Clere, one of the town's bailiffs, should negotiate with the Privy Council for the taking in of Dutch refugees. The settlers who arrived in the 1560s were Protestant refugees, 'banished for godes word' as the original invitation reads, though they were also fleeing from the economic dislocation that accompanied the mid sixteenth-century European religious wars. The first Dutch settlers arrived in 1565, a total of fifty-five people in eleven households. Their numbers grew slowly at first, producing an alien community of 185 by 1571, of whom 177 were Dutch; but the real influx was yet to come, for by 1586 a total of 1,291 Dutch settlers were present in the town. As was the case in London at that time, some individuals returned home, some new settlers arrived, although it is impossible to trace detailed fluctuations in the size of the community over time. Nevertheless, a return of 1622 lists 1,535, constituting roughly one-seventh of the town's total population, and this number was maintained into the mid-seventeenth century.

The Dutch brought substantial economic benefits to the town, just as the urban authorities had hoped. Within a generation the ailing indigenous cloth industry was reborn, shifting away from the heavy and expensive English broadcloths, which had once been the dominant product, towards the lighter, more colourful and cheaper new draperies – a worsted rather than a woollen cloth – which was much more marketable, both economically and geographically. By the early seventeenth century 'bay and sayweavers' featured among the leading trades of the town, and the industry had been taken up by the indigenous as well as the immigrant population. Colchester's population had more than doubled in fifty years, and its cloths earned an impressive reputation in European markets that was to persist throughout the seventeenth century.[7]

While the town authorities were clearly pleased about the economic impact of the Dutch, the scale of the immigrant community in a relatively small town was almost bound to cause difficulties. By 1580 the sheer pressure of numbers led the Corporation to issue an order against further increase, and required the removal of all who were not members of the Dutch Congregation or who had arrived within the past fortnight. No more were to be admitted without written consent of the aldermen and bailiffs, for 'there are a great number of strangers inhabiting within this town presupposed more than the town can well sustain and bear'. The Dutch were successively accused by the populous – in Colchester as elsewhere – of taking away Englishmen's trades, employing only

their own countrymen, producing inferior goods, trading secretly with each other, sending home their profits, forcing up the price of food and accommodation, increasing the risk of plague by overcrowding and even conspiring against the state. Resentment, which came largely from those towards the lower end of the social scale who felt threatened by immigrant competition, surfaced particularly in years of economic depression, but it should not be exaggerated. Many complaints voiced were not directed against foreigners per se, but against perceived abuses of the established rules of commerce that applied equally to indigenous residents and English migrants to the town. And while both the Corporation of Colchester and the Privy Council listened to these complaints, they acted with an even-handedness that left their privileges essentially intact. Violence towards immigrants was rare, the indigenous and immigrant communities co-existing and cooperating with each other, while in the longer term economic, social, political and demographic integration was achieved. It would be a gross injustice, therefore, to characterise the English reaction to the Dutch as 'xenophobic', an accusation I have described elsewhere as 'an epithet too far'.[8] Time and again the immigrant community's privileges were upheld, and they were defended from the unfair criticism that occasionally arose from small sections of the population.

This case study exemplifies many of the features associated with foreign immigration across the centuries. The numbers have often been exaggerated, whether by scaremongers in sixteenth-century London or more recently by politicians such as Enoch Powell in his infamous 'rivers of blood' speech in the early 1960s – a period when West Indian immigrants constituted barely one per cent of the national population.[9] Resentment has emerged most strongly in times of economic depression in both early modern and modern Britain. For instance, the state of the economy provides a temporal and geographical barometer for the fortunes of the National Front and British National Party in the late twentieth and early twenty-first centuries. Scapegoating, with migrants as the common target, is no novelty to recent British history. Resentment has tended to focus upon competition for jobs, while in better times both skilled and unskilled foreign labour has been actively or tacitly welcomed to fill gaps in the British labour market, and too frequently taken for granted – as in the case of nurses, bus conductors and fruit and vegetable pickers – jobs that the indigenous population have been loath to accept at such poor rates of pay. Some immigrants' sojourn has been strictly temporary, others have established significant communities. Many of these communities have developed their own institutions and infrastructures, which have allowed them to maintain their cultures and to provide each other with economic and social support; but in the longer run there is no doubt that integration has taken place, albeit at different speeds

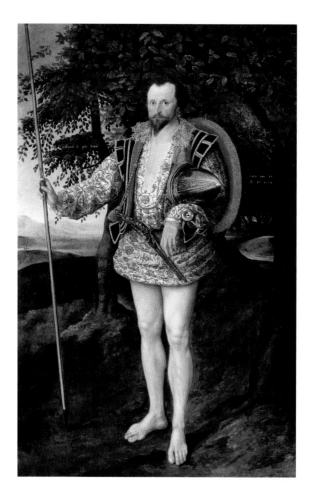

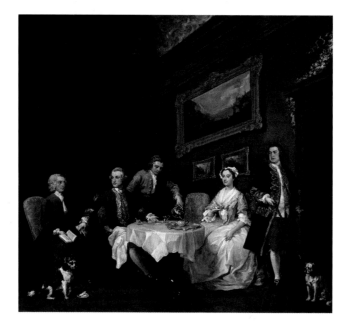

1 Marcus Gheeraerts II (1561 or 2 –1636) *Portrait of Captain Thomas Lee* 1594. Oil paint on canvas 230.5 × 150.8
2 William Hogarth (1697–1764) *The Strode Family* c.1738. Oil paint on canvas 87 × 91.5

among different groups and at different times. Above all, it must be said that social and cultural diversity has been a product – and a highly valuable product – of immigration, while the economic benefits through the introduction of capital, skilled labour and unskilled labour alike has contributed enormously to British economic development from the Middle Ages to the present.

In this brief overview I have concentrated upon the economic impact of, and social reception afforded to, immigrants to the British Isles, without mention of either high or popular culture. These topics warrant chapters in their own right, but as a brief corrective we can again cast our eyes across the centuries to find significant foreign influences upon a great variety of cultural forms. In the sixteenth century the most famous portrait of Henry VIII (c.1537) was, of course, that of the German artist Hans Holbein, who had moved to England in 1526 at the age of twenty-nine, and who also painted portraits of other wealthy dignitaries such as Thomas More and Thomas Cromwell. In the seventeenth century court portrait artists such as John de Critz I and Marcus Gheeraerts II (fig.1) had been born overseas but trained largely within the immigrant community of late sixteenth-century London, while from 1617 a new influx from the Netherlands introduced fresh blood, including Paul van Somer and Daniel Mytens, while after 1632 Anthony van Dyck took over all major Caroline court portrait commissions.[10] Even during one of its more nationalistic phases, in the early to mid-eighteenth century, English art and interior design was heavily influenced by the French Rococo style (fig.2). The fact that the Anti-Gallican Society could be founded in London in 1745 merely highlights the ambivalence in Anglo-French relationships that artistic admiration alongside economic, political and religious rivalry could produce.[11] Finally, and to take a huge chronological and cultural leap, the recent history of British popular music would surely have been profoundly different had it not been for the influence of black musicians, whether classic blues artists such as Muddy Waters, Blind Lemon Jefferson or B.B. King, West Indian reggae musicians such as Peter Tosh or Bob Marley or one of any number of Tamla and Motown artists from 1959 onwards, whose influence can be felt in popular music up to the present day. Like the Dutch and French Huguenots of the sixteenth and seventeenth centuries, the West Indians, Asians and east European incomers of recent decades have, and will continue to, stamp their mark on British society. Cultural diversity, openness and porous national borders may present challenges but they bring many advantages too, and those advantages have been experienced in Britain through several centuries of immigrant history.

Portraiture

One of the most striking aspects of early modern British art, and especially in the fields of painting and sculpture, is how much of it was produced by incomers.[1] This was true particularly of art for the elites – the court, aristocracy and gentry.

In 1531 the courtier and writer Sir Thomas Elyot observed that the English felt compelled, 'if we wyll have any thinge well paynted, kerved, or embrawdred, to abandon our own countray-men and resorte unto straungers [foreigners]'.[2] The leading court painter to Henry VIII was the German Hans Holbein II (fig.3), whom Elyot also chose to portray himself and his wife.[3] Indeed, from about 1550 to the 1690s any royal or aristo-cratic patrons who wanted high quality and style usually chose to sit for artists trained abroad, perhaps because, as Elyot implied, they were dis-satisfied with the local product. So, while little is known about the training of British-born painters in the sixteenth century, it appears not to have been sophisticated enough for elite British clients.

For most of the sixteenth and seventeenth cen-turies numerous craftspeople, including painters, travelled from overseas, especially from the Northern and Southern Netherlands, to work in England and Scotland for varying reasons: some came as religious exiles, others had purely economic motives. These artists, trained in the widest range of genres, found on arrival in England and Scotland that the market for easel paintings was dominated by portraiture. These paintings served various practical purposes: celebrating major life events of the sitter, or conveying a candidate's likeness when a marriage was being negotiated, or, when on open display, demonstrating the sitter or owner's political or familial affiliations.[4] Such portraiture also seems to have been acceptable in a Protestant culture anxious to observe the Second Commandment's prohibition of 'bowing down to graven images'.

Following the re-imposition of Catholic Habsburg rule in the Netherlands in 1567, Protestant England became a refuge for Netherlandish members of the reformed religion, some of whom were artists. Some settled, gaining naturalisation, among them Hans Eworth (originally called Jan Eeuwouts, from Antwerp), who was first recorded as being in London in 1549. After the death of Holbein in 1543 Eworth became a leading court painter in England, and subsequently the princi-pal painter to the Catholic Queen Mary I (fig.4).[5]

Other artists came for only a few years. Marcus Gheeraerts the elder was a prominent member of the Protestant community in Bruges until the Catholic Duke of Alva's campaign there forced him into exile in London with his young son Marcus II in 1567/8. The elder Gheeraerts became a member of the Dutch Reformed group, before returning to the Netherlands in the late 1580s. His son, however, was raised, and presumably trained, in London, and subsequently conducted his entire career there as a second-generation migrant painter (fig.5).[6] He became the principal artist to the elderly Elizabeth I and subsequently to James I's consort, Queen Anne of Denmark.[7]

With the accession of James I, Dutch and Flemish painters began to come to England less for religious reasons than for professional advancement. The most successful of this group of Netherlandish migrants was Daniel Mytens, who was born in Delft around 1590 and was recorded as a freeman at The Hague in 1610. Mytens arrived in London in 1618, where he portrayed many leading court figures. Mytens was Charles I's principal portraitist until the Antwerp-born Anthony van Dyck arrived in 1632, after which Mytens retreated back to The Hague.[8]

England and Scotland (which were separate nations until 1603) were not the only destina-tions for émigré artists. Netherlandish painters,

particularly those of the reformed religion, were also to be found in Denmark, Sweden, Poland, and at the various German courts, where, again, most of the locally trained artists seem to have been unable to compete with them. The indigenous London craftsmen frequently complained that opportunities to work for the court elite were given to foreigners.[9] In certain London parishes incomers could practise their trade outside the jurisdiction of the City guilds, such as in St Anne's Blackfriars, where many Netherlanders therefore chose to live. It was in this parish on the river Thames that Charles I paid for a luxurious residence for the celebrated Flemish painter Anthony van Dyck in the 1630s, indicating how a migrant artist who was employed by the court could work unaffected by the London guild restrictions. Van Dyck worked directly for Charles I and transformed the visual image of the monarchy – combining Flemish baroque energy with a Venetian-style elegance and colour – while his influence on portrait painting in Britain was also to be uniquely powerful and long lasting (figs.6, 7). Almost from the outset other portrait painters in London adopted his compositions and poses for their own works, an appropriation that continued not only during his lifetime, but throughout the rest of the seventeenth century and on through the eighteenth and nineteenth centuries.[10]

The London-born Cornelius Johnson (Cornelis Jonson van Ceulen) was of Flemish and German migrant descent. A prolific portraitist, he achieved solid success during the 1620s and was appointed picture maker to Charles I in December 1632, although he seems to have received only a handful of commissions from the monarch. Then, in the late 1630s, as the political situation in the British Isles worsened, the migrant painters began to return home to the Low Countries. After the English Civil War broke out in 1642 even Johnson migrated to the country of his parents in 1643, where he made a second career; from Middelburg he moved to Amsterdam, and his final years were

spent in Utrecht.[11] Consequently British citizens – primarily Royalists – who were exiled in the Netherlands by the Civil War sought out familiar painters there, such as Johnson and Adriaen Hanneman (who had also worked in London, probably as an assistant to van Dyck), when they wanted to commission a portrait.

Conversely, the Haarlem-trained Peter Lely, a pupil of Frans and Pieter de Grebber, reached London in the early 1640s. Although initially specialising in pastoral scenes, on encountering British portraits by the recently deceased van Dyck, Lely adopted his manner and compositions. It appears that Lely had no difficulty in finding clients in the troubled London of the Civil War and Interregnum period – often among members of the same aristocratic families who had previously sat for van Dyck. This meant that, with Charles II's return in 1660 and the Restoration of the Stuart monarchy, Lely was perfectly positioned to assume van Dyck's mantle as official royal painter, and to reap the full measure of success from that tactic.[12]

Following the Restoration other Netherlandish portraitists established themselves in London. They included Gilbert Soest (presumed a Netherlander), Jacob Huysmans (probably from Antwerp), Pieter Borsselaer, Willem Wissing (trained at The Hague), and Frederick Kerseboom (born in Germany, trained in Amsterdam and also active in Paris and Rome). The prolific Soest received commissions from middle-class, gentry and lesser-nobility clients, while Wissing worked for some of the leading aristocratic families as well as portraying members of the royal family, including the Duke of York's daughters, Princess Mary (and her husband, William of Orange) and Princess Anne (later Queen Anne), and his late wife's nieces (fig.8).

Following Lely's death in 1680, the leading portrait painter at court was the German migrant Godfrey Kneller, who had been partly trained in Amsterdam and was to become principal painter under, successively, King William and Queen

Mary, Queen Anne and King George I (fig.9). Knighted in 1692, Kneller was, unprecedentedly, created a baronet by George I in 1715. Other successful incomers to London included John Closterman from Osnabrück, Germany, and the Swede Michael Dahl, who was favoured by Queen Anne and her Danish consort Prince George.

It was not until well into the eighteenth century that British-born and trained portrait painters such as Jonathan Richardson, Thomas Hudson, and his ambitious pupil Sir Joshua Reynolds were able, at last, to enter the professional British art market at the highest level. This was the outcome of more professional training for painters in Britain, greater opportunities to travel overseas for career development, and the formation of professional associations such as the Society of Artists and the Royal Academy (see pp.32–3).

Karen Hearn

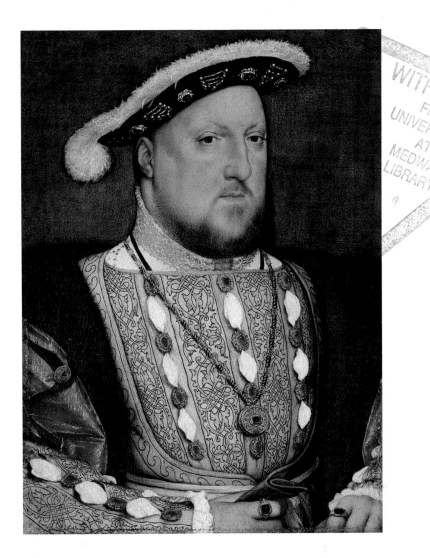

3 Hans Holbein the Younger (c.1497–1543). *Henry VIII* c.1537. Oil paint on oak panel 28 × 20
Museo Thyssen-Bornemisza, Madrid

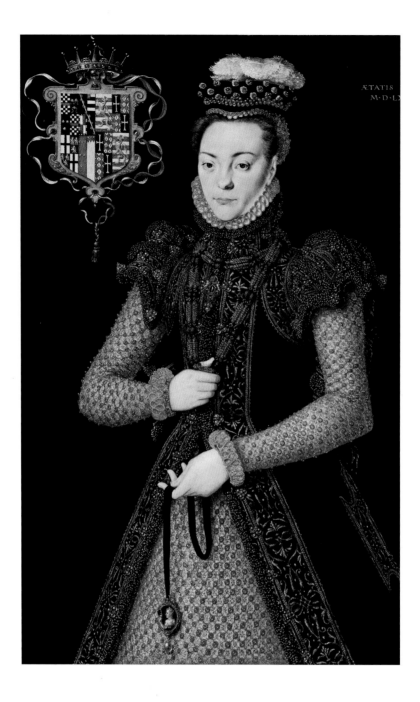

4 Hans Eworth (active 1540–1573) *Portrait of an Unknown Lady* c.1565–8. Oil paint on oak panel 99.8 × 61.9

5 Marcus Gheeraerts II (1561 or 2–1636). *Portrait of Mary Rogers, Lady Harington* 1592. Oil paint on wood 113 × 85.1

6 Anthony van Dyck (1599–1641) *Charles I* 1636. Oil paint on canvas 72.1 × 61.9. The Chequers Trust

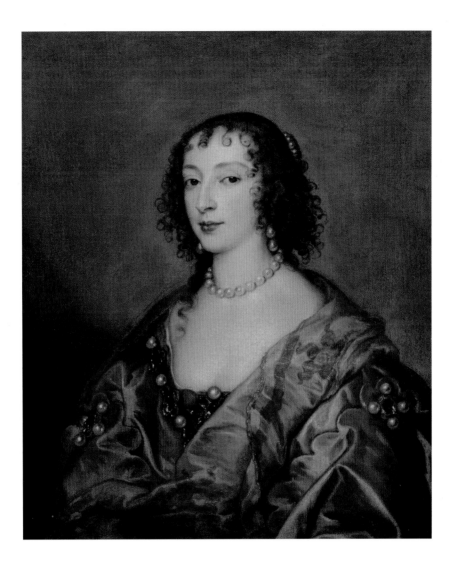

7 Anthony van Dyck (1599–1641) *Henrietta Maria* 1636. Oil paint on canvas 72.1 × 58.4. The Chequers Trust

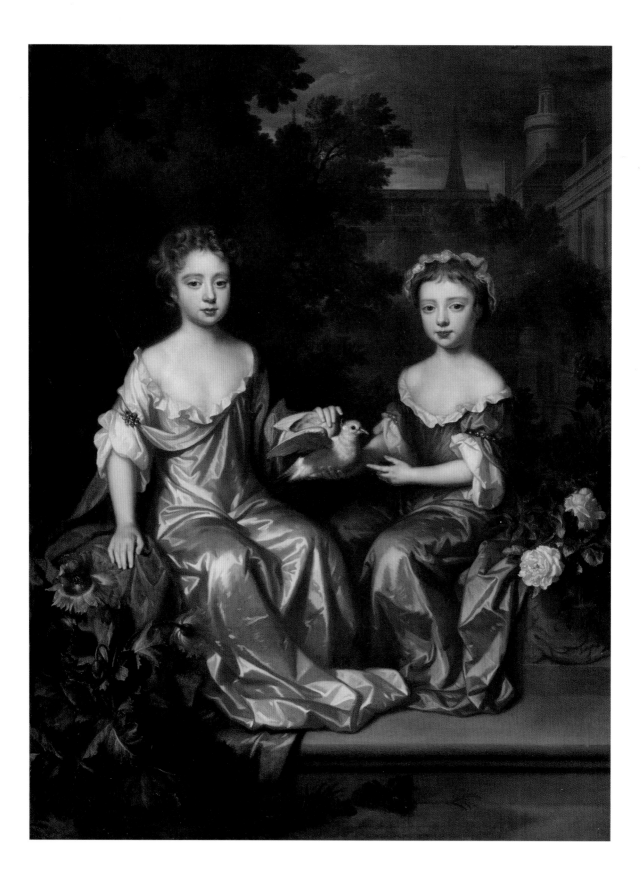

8 Willem Wissing (1656–1687) *Portrait of Henrietta and Mary Hyde* c.1683–5. Oil paint on canvas 153 × 112

9 Godfrey Kneller (1646–1723) *Portrait of John Banckes* 1676. Oil paint on canvas 137.2 × 101.6

New Genres

In the seventeenth century portraiture had been, and was to remain, the principal genre commissioned and appreciated by British patrons. During the course of the seventeenth century, however, artists born and trained overseas introduced a much broader range. Those from the Netherlands specialised in landscape, marine scenes, animals and still-life painting, while Italian and French artists introduced Baroque decorative painting on walls and ceilings. Charles I, who came to the throne in 1625, was passionately interested in art, and his courtiers vied with one another both to acquire works of art from the continent and to commission new works from these overseas-born artists active in London.

From 1617 Hendrick van Steenwijck the Younger worked in London, specialising in small-scale architectural interior scenes, often darkly lit and acting as backdrops to biblical or mythical stories.[1] Landscape painting – today considered such a quintessentially British genre – had rarely been practised in England previously. Indeed, as writer Henry Peacham observed, even the term 'landscape' was borrowed from the Dutch word *landschap*.[2] In the late 1630s the Flemish painter of landscapes and pastoral scenes, Alexander Keirincx, came to London and briefly worked there for Charles I. Significantly, as the political situation worsened, he was commissioned by the king to tour England and Scotland in 1639–40 to paint views of major cities and castles in Charles's domain (fig.10).[3] Between 1637 and 1641 Keirincx shared a property in Westminster (paid for by Charles I) with Cornelis van Poelenburch of Utrecht, who painted small Italianate landscapes on copper or panel, with figures enacting classical scenes, a number of which are also recorded in the inventories of Charles I's collection.

As civil war loomed in Britain artists from abroad began to reconsider their position, with many making the return journey home; Keirincx and Poelenburgh, for instance, departed in around 1641. With the return of Charles II in 1660, however, and the restoration of the Stuart monarchy, English exiles returned with their aesthetic horizons greatly expanded by what they had seen at the French and Dutch courts, where many of them had been living. Landscape painting continued to develop in the hands of incomer artists, and a sub-genre that was to become particularly popular was the 'country house and estate' portrait – a painting that carefully depicted a country property, including its land, and was generally produced by painters from the Netherlands.[4]

The leading exponent was the Antwerp-born and trained Jan Siberechts, whose Flemish work had comprised Italianate wooded landscapes, many including buxom country girls wading through rivers. By 1674 Siberechts was in England, probably at the invitation of the wealthy 2nd Duke of Buckingham, and he seems to have developed this new form of subject matter in his images of country houses, including Longleat House in Wiltshire, Cheveley Park in Cambridgeshire and Wollaton Hall in Nottinghamshire. In 1696 he portrayed the small Belsize house and estate of a London banker called John Coggs (fig.11).[5]

Again, particularly following the Restoration and the consequent return of Royalist exiles, narrative paintings – with religious, classical or secular subject-matter – may have seemed less problematic in what was an ostensibly Protestant British society (fig.14). Roman Catholic clients felt able to commission religious images, and Benedetto Gennari, the nephew of the Bolognese artist Guercino, was not only employed by Charles II and others as a portraitist, but also painted devotional images for Charles's Catholic queen, Catherine of Braganza, and for his Catholic brother, who was to succeed him as James II.[6]

In 1629–30 the celebrated Flemish artist Peter Paul Rubens had come to London on a diplomatic mission and had been commissioned by Charles I to paint nine immense allegorical canvases for the ceiling in the Banqueting House, Whitehall. The Civil War had prevented the initiative from being repeated, but towards the end of the seventeenth century there was a brief explosion of interest in having walls, ceilings and staircases painted – sometimes, as at Hampton Court Palace and Chatsworth, on a considerable scale – by Italian, French and Netherlandish artists. Antonio Verrio came to England at the start of the 1670s to work – as, indeed, many artists from abroad did – for the rich and aesthetically sophisticated diplomat Ralph, 1st Duke of Montagu. Verrio was to be continuously employed by Charles II and his successors, and Verrio's sketch for a ceiling decoration demonstrates on a small scale his command of composition (fig.13). Verrio also worked with the younger Frenchman Louis Laguerre, who painted in many of the great country houses.[7]

Marine painting was largely unknown in Britain until the arrival of the celebrated Willem van de Velde the younger and his father, Willem van de Velde the elder in the winter of 1672–3, in response to Charles II's invitation to Dutch craftspeople to migrate. Charles provided the van de Veldes with a studio at Greenwich. The younger Willem's subject matter changed when he came to England: rather than fishing vessels he began to paint specific boats, such as royal yachts, as well as sea battles and storms, which would influence future generations of English marine painters (fig.12).[8]

Animal and bird painting also emerged around this time. Although there were some English-born practitioners, such as Francis Barlow and Marmaduke Craddock, the most sophisticated pictures were made by incomers, particularly the Hungarian-born Jacob Bogdani, who had also worked in the Netherlands and came to England in early 1688, where he became known as The Hungarian. He had initially painted images of flowers and fruit, and moved on to birds and exotic animals, for King William, Queen Mary and Queen Anne, as well as leading court figures, finding his subject matter in the celebrated private aviary owned by Admiral George Churchill, brother of the Duke of Marlborough.[9]

Still-life painting, once again a Netherlandish tradition, also developed soon after the Restoration. Pieter Roestraten, the son-in-law of the celebrated Haarlem painter Frans Hals, is thought to have settled in London by 1666. He specialised in still-life paintings of luxury goods, such as vessels of precious metal or ivory.[10] The Leiden painter Edward Collier travelled between the Netherlands and London, turning out numerous still-life paintings that included such objects as books, newspapers, documents (with works for English clients featuring English texts), globes, medals, jewellery, musical instruments and precious tableware. Collier often repeated compositions with only small alterations, but the large number of his surviving works indicates their popularity.[11]

Portrait sculpture, too, was the province of overseas-born makers. During the reign of Charles I the handful of practitioners included the Frenchman Hubert Le Sueur and the Italian Francesco Fanelli.[12] At the end of the seventeenth century the genre was revived by the Netherlanders John Michael Rysbrack, Peter Gaspar Scheemakers and the Frenchman Louis François Roubiliac.

Thus, by the early eighteenth century, artists in Britain were producing a far broader and more innovative range of subject matter than had been available a century earlier – and gradually locally born and trained practitioners were to take control of the genres that had crossed over from the incomer artists.

Karen Hearn

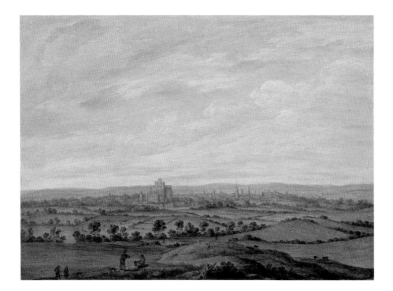

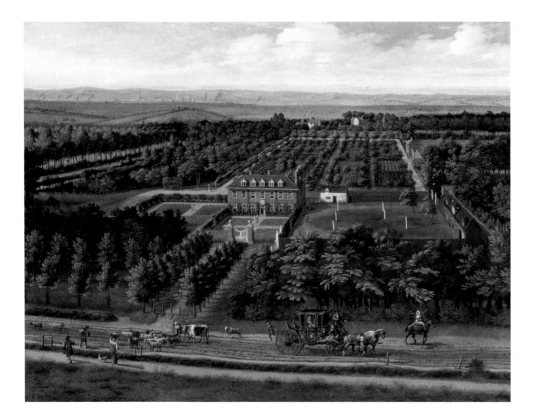

10　Alexander Keirincx (1600–1652) *Distant View of York* 1639. Oil paint on oak panel 52.9 × 68.7
11　Jan Siberechts (1627–c.1700) *View of a House and its Estate in Belsize, Middlesex* 1696. Oil paint on canvas 107.9 × 139.7

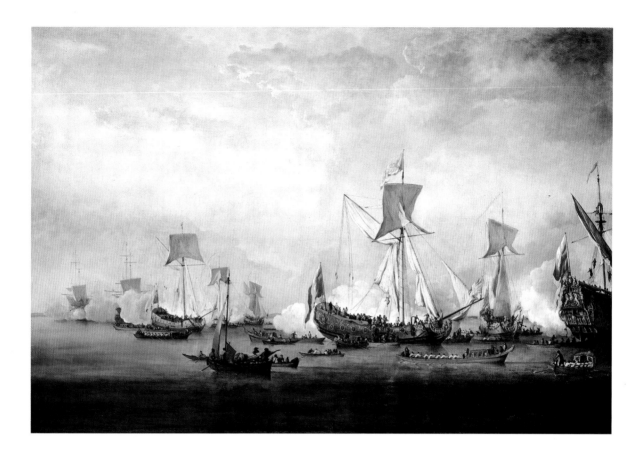

12 Willem van de Velde the Younger (1633–1707) *The Departure of William of Orange and Princess Mary for Holland, November 1677* 1677. Oil paint on canvas 127 × 182.9. National Maritime Museum, Greenwich, London

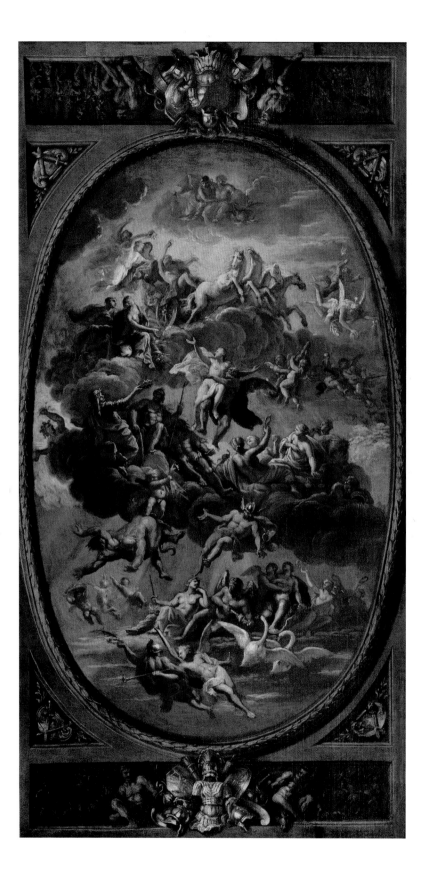

13 Antonio Verrio (1639–1707) *Sketch for a Ceiling Decoration: An Assembly of the Gods* c.1680–1700. Oil paint on canvas 169.2 × 82.9

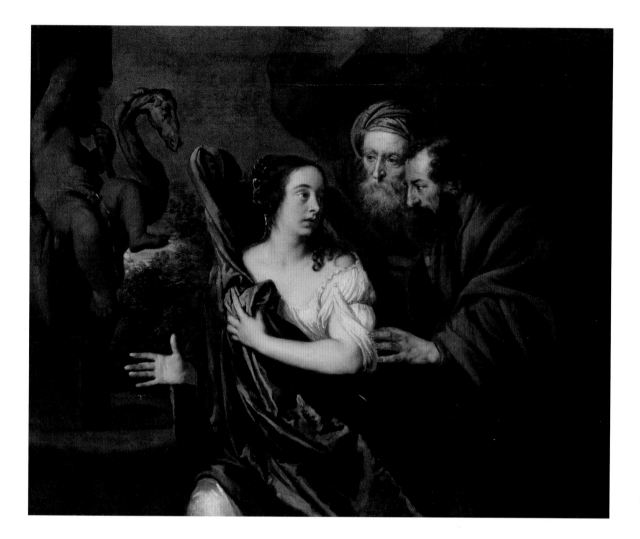

14 Peter Lely (1618–1680) *Susanna and the Elders* c.1650–5. Oil paint on canvas 127 × 149.2

Italy, Neoclassicism and the Royal Academy

Italy was a place of immense interest for artists and travellers in the eighteenth century, as it was the apotheosis of a past that was becoming increasingly current. Rome in particular was a nodal point for international travel, as remnants of its classical civilisation were being rediscovered through archaeological digs, renewing scholarly interest as well as creating a modern tourist industry. Many young men from the highest ranks of society left Britain to experience the great cities of continental Europe on their Grand Tour – an essential part of a gentleman's education; and for which Italy was an imperative destination. Artists, too, were drawn to the country, to study and learn from antiquity and the old masters, as well as to socialise and share ideas with other artists and meet potential patrons.[1]

Neoclassicism developed from this renewed interest in classical forms, as well as in reaction to the overly decorative Rococo style that had been recently dominant. Many neoclassical artists travelled to London to seek their fortune and became integral to the foundation and development of the leading British arts organisation, the Royal Academy, which promoted these new artistic ideals through the annual lectures of its President, Sir Joshua Reynolds. The phenomenon consequently influenced all aspects of art and design in late eighteenth-century Britain, from painting and sculpture to architecture and interior design.[2]

For wealthy British tourists passing through Venice in the 1730s Canaletto (Giovanni Antonio Canal) painted views of the city as mementos of their stay. The outbreak of the War of Austrian Succession in 1740 severely restricted the numbers of travellers, however, and lucrative sales dried up. In 1746 Canaletto left Italy for London, encouraged by his fellow Venetian artist Jacopo Amigoni, the decorative painter who had worked in England 1729–39 and suggested that Canaletto might paint views of the Thames instead of the canals of Venice. Canaletto stayed in England for nine years (with a brief return to Venice in 1751–2), painting numerous views of London landmarks and the English landscape. As well as fulfilling commissions from clients and attracting new patrons, he also produced a few speculative works for sale. *London: The Old Horse Guards from St James's Park* (fig.15) is almost certainly the work featured in the *Daily Advertiser* on 25 July 1749, which invited readers to view the painting at Canaletto's house in Soho.[3]

The social scene in Italy was important in seeding many of these cultural cross-pollinations. The artist and writer Anton Raphael Mengs and the classical historian and archaeologist Johann Joachim Winckelmann encouraged a new appreciation of and engagement with the classical art of the past. According to them, the highest form that artists should strive for was that of history painting – depicting scenes from ancient myths and the classical history of Greece and Rome – while the style of art should promote order, harmony and idealised beauty, and encourage learning, moral guidance and virtue.

The American artist Benjamin West became a leading proponent of neoclassicism and a dominant figure in British art of this period. Trained in Philadelphia, where he enjoyed success with his society portraits, West received patronage to travel to Italy in 1760. On arrival in Rome he studied under Mengs at the Capitoline Academy, who encouraged his pursuit of history painting. In 1763 West arrived in London and in 1766 exhibited a number of his works at the Society of Artists, including *Pylades and Orestes Brought as Victims before Iphigenia* (fig.16), which depicts a scene from Euripides's tragedy *Iphigenia in Tauris*, describing events following the Trojan War. West remained in England for the rest of his life as one of the country's most successful artists.[4]

The Venetian painter Francesco Zuccarelli visited London for long periods: in 1752 for ten years and then again 1765–71. *A Landscape with the Story of Cadmus Killing the Dragon* (fig. 17) exemplifies Zuccarelli's fusion of history and landscape painting in a scene from Ovid's *Metamorphoses* where Cadmus slays the dragon that killed his companions on their journey to Thebes. When working in Venice in 1751, before this painting's exhibition in London in 1756, Zuccarelli was visited by the Welsh painter Richard Wilson, who painted his portrait in return for one of his landscapes.[5] Wilson would go on to paint classical landscapes of Italy and classicised views of the British landscape, but interestingly, despite such classical inflections, George III favoured the paintings of the migrant artist Zuccarelli over those of Wilson.[6]

Nathaniel Dance-Holland was in Italy 1754–66 and, along with the Scottish painter Gavin Hamilton, became a leading British exponent of neoclassical history painting. His depiction of the meeting of the Trojan prince Aeneas and the Carthaginian queen Dido (fig. 18), from Virgil's epic poem *Aeneid*, typifies his work at this time. He painted this while in Rome and sent it for exhibition in London, possibly as an advertisement for his imminent return to Britain. As a long-term resident in Rome, he became acquainted with artists as they arrived in the city, including the young Angelica Kauffman.[7] The Swiss-born Kauffman, a prodigy in languages, music and art, trained as a painter under her father and travelled with him to Italy in 1759. Passing through Florence in 1761 she met West and, arriving in Rome the following year, formed friendships with Hamilton and Dance-Holland, who encouraged her to pursue history painting and study antiquity. In 1766 she met Lady Bridget Wentworth Murray, the wife of the British Resident in Venice, who invited her to travel to England. Within a week of arriving in London she visited the studio of Joshua Reynolds; they became great friends and painted portraits of each other.[8]

Reynolds stayed in Rome 1750–2, making visits to the other Italian cities of Florence and Naples. The work of Michelangelo left a lasting impression on him, and he became a champion of history painting and the classical tradition, which he described and interpreted as the 'great style' to which all painters should aspire. The British taste in art still favoured portraiture, however, so these ideals were adapted by artists to suit the British art market (fig. 19). In 1768 George III signed the Instrument of Foundation of the Royal Academy of Arts, with Reynolds elected as President. In its structure, teaching and membership, the Royal Academy was heavily influenced by foreign institutions and artists. Of the thirty-four founder members ten were migrant artists working in Britain, including West, Kauffman and Zuccarelli. Two nominated members were added shortly afterwards, one of whom was the German painter Johan Zoffany. The membership diploma was designed and engraved by Italians Giovanni Battista Cipriani and Francesco Bartolozzi, while the Italian sculptor Agostino Carlini sculpted a classical bust of their royal patron, George III (fig. 20). West later succeeded Reynolds as President.[9]

Towards the end of the eighteenth century the turmoil and horror of the French Revolution and wars with France limited travel and generated fear and suspicion of foreigners. Increasingly, the foreign members of the Royal Academy were marginalised in favour of British artists.[10] In 1790, when the Italian architect Joseph (Giuseppe) Bonomi was opposed in his election to the post of Professor of Perspective, Reynolds resigned the Presidency in protest, writing an *Apologia* that complained of illiberality and national prejudice.[11] Having contributed so much to the development of the British school, foreign artists were now being sidelined – a repercussion of Britain's widespread consolidation of its position as a leading colonialising power.

Tim Batchelor

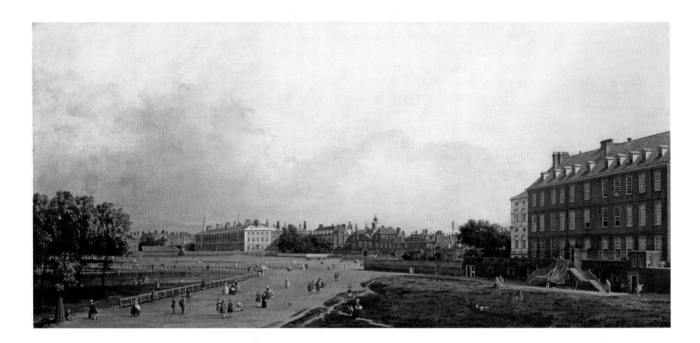

15 Canaletto (1697–1768) London: *The Old Horse Guards from St Jame's Park* c.1749. Oil paint on canvas 117.2 × 236.1
Lent by the Andrew Lloyd Webber Foundation 2000

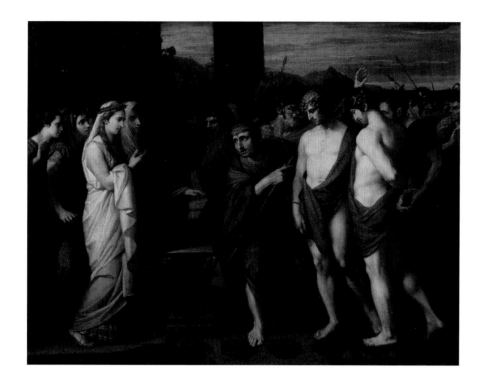

16 Benjamin West (1738–1820) *Pylades and Orestes Brought as Victims before Iphigenia* 1766. Oil paint on canvas 100.3 × 126.4

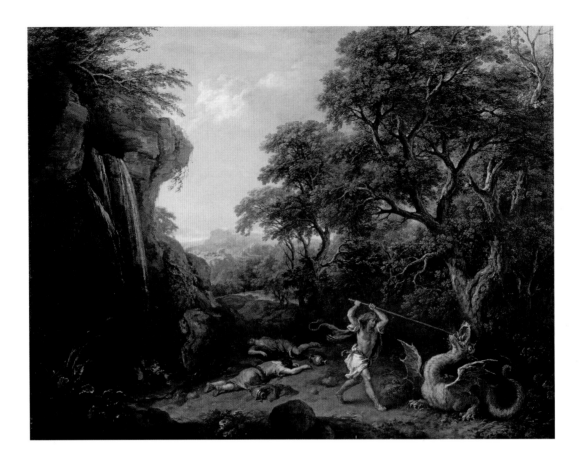

17 Francesco Zuccarelli (1702–1788) *A Landscape with the Story of Cadmus Killing the Dragon* exh.1765
 Oil paint on canvas 126.4 × 157.2

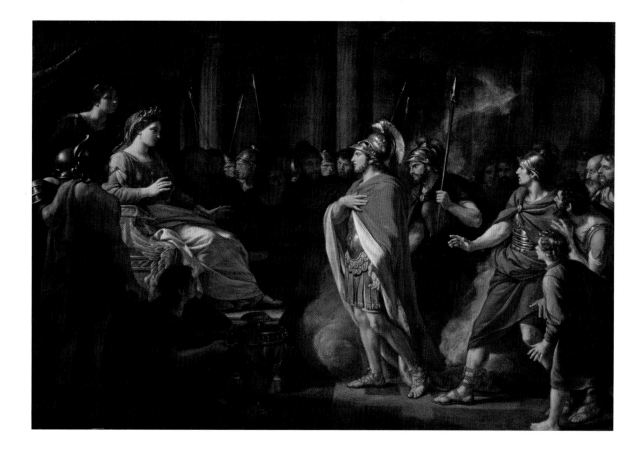

18 Nathaniel Dance-Holland (1735–1811) *The Meeting of Dido and Aeneas* exh. 1766. Oil paint on canvas 124 × 174

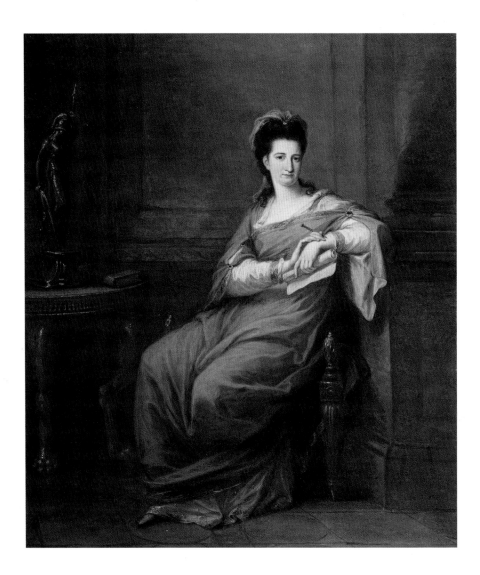

19 Angelica Kauffmann (1741–1807) *Portrait of a Lady* c.1775. Oil paint on canvas 91 × 77

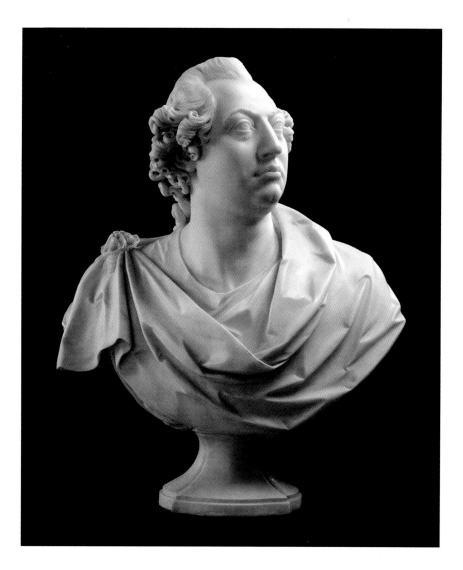

20 Agostino Carlini (c.1718–1790) *Bust of George III* 1773. Marble 81 × 60 × 38. Royal Academy of Arts, London

Dialogues between Britain, France and America

The extensive interchange of artists and ideas between Britain, France and America in the second half of the nineteenth century was partly due to political turmoil, and partly to the distinct opportunities for art education and career advancement that different artistic centres provided. Paris was the acknowledged capital for art training at this time, offering a combination of official schools, such as the École des Beaux-Arts, and private studios run by some of the most eminent French artists. Many British and American artists studied in Paris to take advantage of the superior tuition on offer and establish their names at the Paris Salon before settling in London.[1] In contrast to the political instability and economic hardship that Paris experienced periodically until the 1880s, London continuously remained a stable and prosperous commercial centre and offered greater opportunities for private patronage. The Royal Academy exhibitions were supplemented by a thriving group of smaller galleries showing more progressive art, and there was a ready supply of collectors who had made their money in banking, trade or industry and were interested in buying contemporary art.[2] Personal contacts were paramount to successful migration, and links with British artists who had studied and exhibited in Paris, or fellow émigrés already settled in London, would prove vital for French and American artists establishing themselves in the city. French and American artists had a significant impact on British art through their involvement in art education and through their circles of pupils and followers, and while they brought new styles and conventions to Britain, often their own work changed to accommodate the preoccupations of British patrons and galleries.

James McNeill Whistler moved from America to study in Paris in November 1855. Here he became friends with English students Edward Poynter and Charles du Maurier,[3] and met young French painters Henri Fantin-Latour and Alphonse Legros, with whom he formed the Société des Trois in spring 1859 to promote their shared interest in the realist art of Gustave Courbet.[4] In May 1859 Whistler moved to London, although he continued to visit Paris regularly and to exhibit there. Whistler's family connections in London may have prompted his move, but the success of *At the Piano* 1858–9 at the Royal Academy and the admiration of young British artists John Everett Millais, William Holman Hunt and the President of the Royal Academy Sir Charles Eastlake must also have influenced his decision to stay.[5]

In London Whistler received prestigious commissions for portraits and decorative schemes, and found a ready market for his etchings. In 1867 the shipping magnate Frederick Leyland commissioned him to produce a decorative scheme of six figure subjects for his house in Kensington. Whistler's work had moved away from his early engagement with French realism to incorporate the Japanese and classical sources that also inspired the work of contemporaneous British artists such as Albert Moore. Although the scheme was never executed, one of the compositions was later developed by Whistler as *Three Figures: Pink and Grey* 1868–78 (fig.21).[6] In the early 1870s Whistler developed a new approach to depicting the river Thames, in which he kept representation of physical features to a minimum, instead focusing on the shifting atmospheric effects of light. He titled these works 'Nocturnes' to draw an analogy between musical harmonies and the colour harmonies that were the primary subject of paintings such as *Nocturne: Blue and Silver – Cremorne Lights* 1872 (fig.22). Whistler's first nocturne, *Nocturne: Blue and Silver – Chelsea* 1871 (Tate), was bought by the banker W.C. Alexander, who went on to commission paintings of his daughters Cicily and Agnes Mary ('May'), among

them *Miss Agnes Mary Alexander* c.1873 (fig.23). Whistler quickly made an enduring impact in the London art world. His own work was highly influential in its focus on the visual effect of paintings rather than their content, his reputation attracting a circle of followers and pupils with a diverse range of nationalities, including Walter Sickert, Theodore Roussel and Mortimer Menpes, many of whom went on to have a significant impact on British art.

Alphonse Legros had emerged as the leader of a younger generation of realists in Paris following critical acclaim for his painting *Ex-Voto*, exhibited at the Salon of 1860. He moved to London in 1863 – encouraged by Whistler and attracted by the possibility of patronage from the wealthy Ionides family – where he quickly established a circle of artist friends and married an English woman in 1864.[7] Legros continued to exhibit in Paris, but made his career in London, showing regularly at the Royal Academy, where his resolutely French style found an appreciative British audience.[8] In the latter part of his career Legros established himself as an important figure in British art education and succeeded Edward Poynter as Professor at the Slade School of Fine Art in 1876. Legros's teaching continued Poynter's emphasis on life drawing, but he also introduced etching and modelling classes to the curriculum. Legros never learnt to speak English and taught French methods of drawing and painting by demonstration, becoming renowned for his rigorous linear drawings and system of painting portraits direct from life in one sitting.[9] His students included William Rothenstein, Henry Scott Tuke and William Strang, who all went on to become influential figures in the London art world. London had little impact on the content or style of Legros's own paintings however. He continued to produce images of French peasant life in an earthy toned palette, remaining so true to his French realist roots that his obituary stated 'to the end he and his art remained essentially French'.[10]

French and American artists moving to London in the late 1850s and 1860s did so primarily for career reasons, but by the early 1870s the Franco-Prussian War in Europe provided a new impetus for migration, with such artists as Claude Monet and Camille Pissarro taking refuge in London between 1870 and 1871.[11] Unlike the artists that had fled to London to escape the Franco-Prussian War, James Tissot had participated in the defence of Paris against the Prussian army. His move to London in 1871 has sometimes been interpreted as an attempt to avoid reprisals for associating himself with the Paris Commune, an impromptu republican administration which temporarily supplanted the official French government, but it is likely that a desire to advance his career also played a part.[12] He had existing professional contacts in the city, having exhibited at the Royal Academy from 1864 and worked as an illustrator for *Vanity Fair* from 1869.[13] He spent over a decade in England, establishing himself as a successful painter of scenes of fashionable leisure and modern life, adapting his work to cater for the British taste for narrative painting.[14] Many of Tissot's paintings are concerned with the female subject as both the subject of the male gaze and as the initiator of a suggestive exchange of looks. In *The Gallery of* HMS *Calcutta* 1876 (fig.24), for example, Tissot focuses on a flirtation between a young naval officer and a lady with a fan; and in paintings such as *Portrait* 1876 (Tate) the viewer is implicated within an ambiguous social situation by the woman's gaze.[15] Despite the initial success of Tissot's work in England, his attention to surface details of costume and setting and the lack of a clear moral direction to his narratives proved increasingly problematic for English critics. Tissot's women and the social situations in which they were depicted were perceived as being at the boundaries of respectability, particularly in his series of suburban interiors and gardens, where critics noted how their posture and clothing evoked the morally ambiguous image of the

fashionable kept woman.[16] Tissot's subjects both destabilised categories of respectable British femininity, and had uncomfortable echoes of his own well-known liaison with an English divorcee.[17] His hybrid social status was echoed by the fusion of traditions in his art, and the equivocal reactions to it were partly due to its combination of French and British conventions: the profusion of costume detailing evoked the superficial frivolity of French fashion plates, while the suggestion of narrative was thoroughly British, but lacked the clear moral message characteristic of native narrative painting.

John Singer Sargent was born in Florence to expatriate American parents and studied in Paris between 1874 and 1878, making his debut at the Paris Salon in 1879, and establishing himself as a successful portrait painter of French and American sitters. In 1884 the exhibition of his painting Madame X 1883–4 (Metropolitan Museum of Art, New York) caused a scandal at the Paris Salon. The portrait, which exists in two versions (Study of Mme Gautreau c.1884; fig.25), depicts the American society beauty Virginie Avegno, the wife of Pierre Gautreau. When the portrait was exhibited criticism focused on the unconventional nature of the pose, the indecency of the décolleté of the dress and the sitter's excessive use of cosmetics to produce a corpse-like pallor, insinuating that this also revealed her moral corruption. Gautreau was so upset by the reaction that she begged the artist to withdraw the portrait from the Salon.[18] The incident precipitated Sargent's move to London in 1886, where he had previously exhibited at the Royal Academy to great acclaim in 1884. Here he quickly established himself as a society portrait painter. Although his work was first seen as quintessentially French, his later work drew on the historical conventions of British aristocratic portraiture to portray the upper classes.[19] However, this was an upper class in flux and the wealth and influence of the aristocracy was diminishing as families, who had made their money in trade, industry or banking,

joined the elite. Émigrés played their role in this social mobility, with American heiresses marrying into the British aristocracy and Anglo-Jewish bankers buying country estates to claim a place in the upper echelons of society.[20] Sargent's portraits also played their part in this transformation. To have one's portrait painted by Sargent, who had become the most fashionable society portraitist in England by the end of the nineteenth century, was another sign of wealth and success.

The London art dealer Asher Wertheimer commissioned twelve family portraits from Sargent. Ena and Betty, Daughters of Asher and Mrs Wertheimer 1901 (fig.26) was applauded as a tour de force when it was exhibited at the Royal Academy in 1901, where reviewers praised its vitality and its lack of contrivance and academicism.[21] Kathleen Adler has argued that Sargent engaged directly with visual stereotypes of Jewishness in his depictions of female Jewish sitters, evoking exoticism and sexuality as a means of investigating contemporary definitions of femininity and expanding the expectations of society portraiture, but the Wertheimer portraits are also sympathetic portrayals of the family's success and a mark of the extent to which British society was shifting in this period.[22] Sargent's interest in examining Jewishness also has to be read in the context of his wider interest in stereotypes and society in general. As Elizabeth Prettejohn has observed, Sargent's portraits often both present an individual personality and examine a social type, with Madame X representing the professional beauty and the artist W. Graham Robertson 1894 (Tate), the quintessential dandy. Sargent was one of the first truly international artists, and his sympathetic portrayals of Jewish social mobility are made from the perspective of an outside observer, a position that allowed the émigré artist to comment acutely on the shifting contours of British society.[23]

Emma Chambers

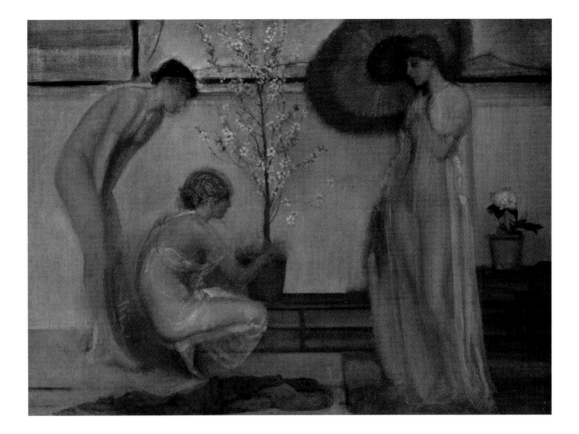

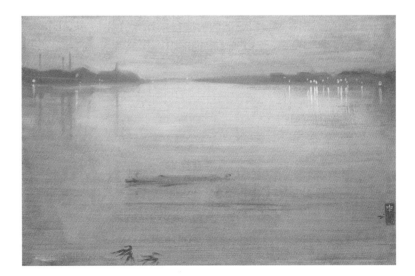

21 James Abbott McNeill Whistler (1834–1903) *Three Figures: Pink and Grey* 1868–78. Oil paint on canvas 139.1 × 185.4
22 James Abbott McNeill Whistler (1834–1903) *Nocturne: Blue and Silver – Cremorne Lights* 1872. Oil paint on canvas 50.2 × 74.3

23 James Abbott McNeill Whistler (1834–1903) *Miss Agnes Mary Alexander* c.1873. Oil paint on canvas 192.4 × 101.6

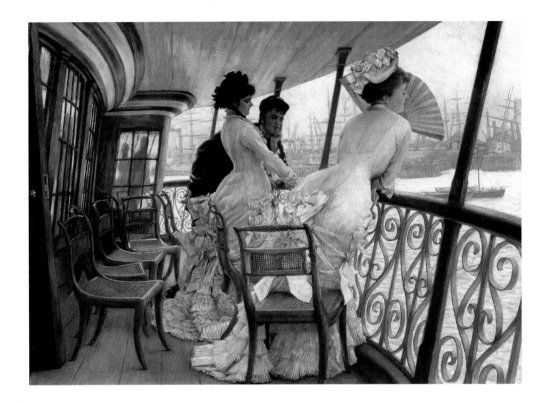

24 James Tissot (1836–1902) *The Gallery of* HMS *Calcutta (Portsmouth)* c.1876. Oil paint on canvas 68.6 × 91.8

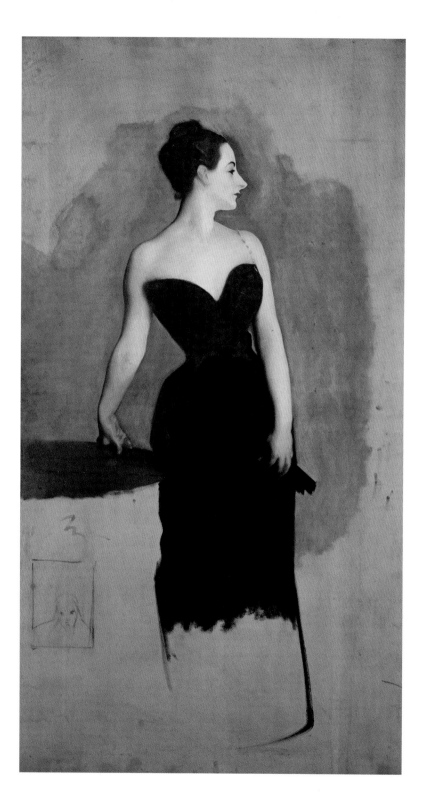

25 John Singer Sargent (1856–1925) *Study of Mme Gautreau* c.1884. Oil paint on canvas 206.4 × 107.9

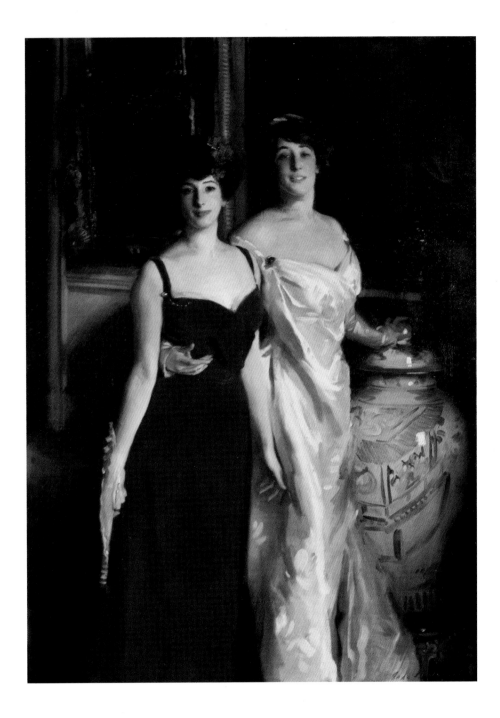

26 John Singer Sargent (1856–1925) *Ena and Betty, Daughters of Asher and Mrs Wertheimer* 1901. Oil paint on canvas 185.4 × 130.8

Migration to Britain since 1800 Panikos Panayi

Despite simplistic assumptions about British national identity, it is impossible to conceptualise the country without considering the importance of immigration over the past two hundred years. As many as ten million people may have made their way to Britain since 1800, without whom the country would look completely different. There would be less diversity in physical appearance, greater dress conformity and a more uniform and blander diet. [1]

Between c.1800 and 1945 migrants came mainly from within Europe, particularly Ireland but also Germany, France and Poland. Polish emigrants included Jews fleeing Tsarist oppression, and those who later fought for Britain during the Second World War and had no desire to return to a Soviet-run Poland. During this hundred and fifty year period some did come from beyond Europe, but until the end of the war most British people would never have encountered an Asian or black person. However, since then numbers have increased significantly, particularly of those from former British possessions in South Asia, the Caribbean, and, in recent decades, from Africa and South America, many of them refugees from intolerant regimes. Amongst this broader internationalisation, movement has also continued within Europe, again, particularly from Ireland, but also from Italy, Cyprus, France and Germany, while recent European Union expansion has led to millions of people making their way from Eastern Europe.

Many of those who have migrated to Britain have left poorer economies, while others have found the relative freedoms enjoyed by Britons attractive. Behind the impersonal statistics lie countless individual stories. Some migrate because of pre-established connections with the country of destination, which, in the case of Britain, includes imperialism. Others have occupational connections, as in the example of German bakers working as apprentices in London and elsewhere during the late-nineteenth century. Familial links have proved most important, with individuals often moving to reunite with relatives.

Most who have settled in the country over the last two centuries have been employed in manual labour, from the mid-Victorian Irish who helped to construct Britain's industrial infrastructure to the West Indian and South Asian newcomers who worked in factories nationwide after the Second World War. To be near their workplace they mainly lived in inner cities, leading to population concentrations such as the Irish in nineteenth-century Liverpool and the Jews in the East End of London in the first half of the twentieth century. But while a link between ethnicity and poverty remains today – as the 50 per

cent unemployment rate among descendants of some post-1945 migrant groups makes clear – it is not automatic. In the first place, if we take a multi-generational approach, social mobility does occur, most clearly indicated by descendants of the East End Jews, who left the area in the 1920s and by the 1960s had become one of the wealthiest ethnic groups in the country. Secondly, not all migrants enter the country in poor circumstances: for example, those who fled the Nazis were predominantly middle class. A significant percentage of migrants have become self-employed, including Greek Cypriots, South Asians and Turks who entered the catering trade after 1945. This follows a long-established pattern of German migration in particular, which in the nineteenth century included businessmen who established the forerunners of firms such as Imperial Chemical Industries.

All migrant groups in Britain have faced, at some time or another, hostility, a phenomenon most durably manifest in the labour market: Afro-Caribbeans, for example, have experienced some of the highest unemployment rates in the post-war period. The British state has been found to practice institutional racism, with studies revealing major issues in policing and the judiciary in particular. In times of war the British state has taken virtually any measures deemed necessary to protect national security against the 'enemy within', which during the Second World War led to the internment and deportation of thousands of Italians and German Jews. But the most intolerant period in British history occurred during the First World War, when both state and society ethnically cleansed itself of its German population through a policy of internment, deportation and property confiscation.

In liberal, democratic Britain governments have bent to the will of the electorate and enacted policies with a racist agenda behind them: immigration legislation, beginning with the Aliens Act of 1905, has evolved against a backdrop of common hostility towards succeeding groups of immigrants. This animosity manifests itself in three main ways. Firstly through an influential and substantial section of the press, which since the arrival of Jewish immigrants from eastern Europe at the end of the nineteenth century has displayed its displeasure at those deemed to be undermining 'the British way of life', atrophying the living and working conditions of Britons and perceived as threatening sexual norms. Secondly, a number of racist political groups have emerged since the Edwardian period, from the British Brothers League to the British Union of Fascists to the National Front to, most recently, the British National Party and the English Defence League. And thirdly, animosity has also manifested itself as street violence against ethnic minorities, which, like press hostility, has changed focus from one group to another: from the Irish in the mid-nineteenth century to Jews to Germans and then,

post-war, to newcomers from the Empire and the Commonwealth. While rioting was normal in the century or so after 1850, this form of mass violence has disappeared since the early 1960s, although attacks on individuals have continued.

Despite prejudice and discrimination, part of the process of migration involves the development of ethnicity. We might suggest a simple route in which newcomers bring with them and recreate their original practices from their homelands. This can be seen in the case of large scale Irish migration re-establishing the Roman Catholic church during the Victorian era (fig.27), the Jewish faith becoming a mass religion before the First World War and, on a smaller scale, German churches springing up around the country. Migrants from South Asia spurred the growth of non-Christian religions in the form of Islam, Hinduism and Sikhism so that mosques, Hindu temples and Sikh Gurdwaras have become as much a part of the British urban landscape as the Roman Catholic churches and synagogues that emerged during the late nineteenth and early twentieth centuries.

The place in which religion is first practiced by an immigrant group is often not a temple or church but a house, which demonstrates how transplantation of original practices within the British environment rarely occurs without some transformation taking place during the migration process itself. For individuals and communities ethnicity employs elements from both the land of origin and Britain, a fact that becomes particularly clear in an examination of food. At the end of the nineteenth century Jews brought dishes from Eastern Europe, but also quickly adopted the eating patterns of the ethnic majority. In the short run, they continued to practice kosher eating, but many post-1945 descendants of the original migrants eventually abandoned this, although some still avoid the most offensive products and many return to ancestral foods on holy days such as Passover. Muslims and Hindu and Sikh vegetarians, meanwhile, found it difficult to continue with their dietary practices in Britain and tended to abandon them, at least temporarily. However, with the increasing numbers of people from India, Pakistan and Bangladesh from the 1960s onwards, a market emerged for South Asian foods which became more readily available, albeit in western packaging sold by firms established in Britain. Similarly, while the consumption of halal meat may have increased, it does not always come in the form of north Indian 'curries', but also in (pork free) fried breakfasts and in other 'British' products such as pies.

Immigrants have also proved central to the evolution of eating out in Britain, a process that began in the second half of the nineteenth century with the arrival of chefs, waiters and restaurant owners from Switzerland, France,

Italy and, above all, Germany. During the course of the nineteenth century some of the leading chefs and food writers, such as Charles Elmé Francatelli, Alexis Soyer and August Escoffier, were of continental origin. European migrants established some of the major London hotels and restaurants, including the Café Royal and the Ritz, and by the outbreak of the First World War around 10 per cent of waiters in London were German, although these would soon face internment and subsequent deportation. Nevertheless, other nationalities soon replaced them, including many Italians, who in turn would be incarcerated and expelled during the Second World War, often to be replaced by Greek Cypriots. It was the Italians who introduced ice cream to Britain in the nineteenth century and played a major role in its popularisation during the course of the twentieth. Perhaps most surprisingly immigrants have proved important in the provision of fish and chips too – a dish that is likely to have French, Belgian and Jewish origins. By the 1920s Jews owned about 20 per cent of the fish and chip shops in London, but since the Second World War Greek Cypriots, Turks, Turkish Cypriots, Italians, Chinese and South Asians have also become prominent purveyors of this quintessential 'British' dish.

Greek Cypriots opened all sorts of eating establishments the length and breadth of the country from the late 1940s onwards. While those in London often sold Greek food, elsewhere the products bore were no obvious traces of the ethnicity of the shops' owners. By the 1960s food in Britain had increasingly become commodified along lines of national taste, partly due to immigrants setting up restaurants and selling a version of ethnic food altered to be more attractive to British palates. From the 1940s until the 1960s restaurant pioneers were mainly Chinese and Italian, but since then 'Indian' food, sold primarily by Bangladeshis, has become increasingly popular. British consumers, enjoying these 'foreign' foods, wished to consume them at home, which led to the evolution of the takeaway and the ready meal, now a staple of the British diet. The role of immigration in the evolution of British eating patterns offers just one example of the impact of immigration upon the country (fig.28).

Migrants have also played a leading role in the evolution of sport and music. In recent decades football's Premier League has hosted many foreign stars. To these we should also add those footballers of African and Afro-Caribbean origin, which means that a majority of those playing for Britain's top clubs either consist of highly skilled migrants or the descendants of post-War settlers. An examination of music would not simply point to the importance of people of Afro-Caribbean origins in the evolution of pop music, but also the role of Germans in the development of orchestras during the nineteenth century.

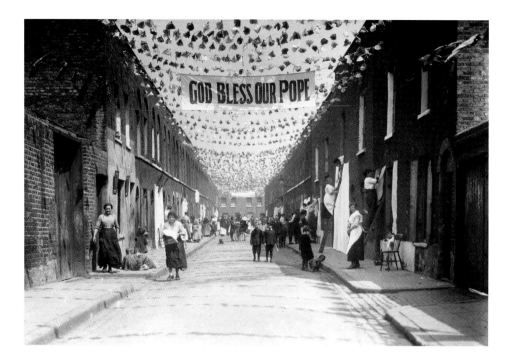

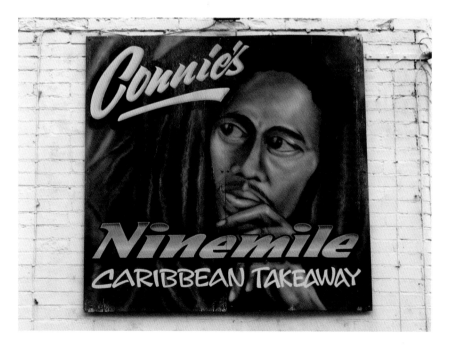

27 Irish Roman Catholic celebration in East London in 1914
28 A restaurant placard in Leicester, photographed by the author 2011

Immigration has had a profound impact on Britain over the last two centuries. Many groups have faced a range of hostility from British state and society. However, despite the existence of tight controls since 1905, millions of people have made their way to the country and, over time, they and their descendants have increasingly integrated into the mainstream. The arrival of newcomers continues to transform the urban geography, fuel the economy. and contribute to the cutltural life of Britain.

Jewish Artists and Jewish Art in London

In 1901 the successful Victorian painter and future Royal Academician Solomon J. Solomon wrote: 'Some years ago the Editor of an Art Journal requested me to write for him an article on Jewish art. I replied that I could more easily write an apology for its non-existence'.[1] Yet the early twentieth century saw sustained debate about the nature of Jewish art, and artists from Jewish émigré communities made significant contributions to the identity of British art. Jewish artists, like Jewish émigrés, were not a homogenous group, but divided by both class and nationality. There were clear distinctions between those, like William Rothenstein, whose parents were mid nineteenth-century migrants from Western Europe who had quickly assimilated with the British middle classes, and a younger generation of artists such as David Bomberg, whose families had arrived from Eastern Europe in the late nineteenth century, and whose parents were modest tradesmen in London's East End.[2] Two influential exhibitions at the Whitechapel Art Gallery in 1906 and 1914 explored very different definitions of Jewish art at a time when Jewish immigration to Britain was the subject of intense debate.[3]

From 1881 Jewish immigration from Russia and Eastern Europe to Britain and America had substantially increased, prompted by pogroms, discriminatory legislation and economic hardship. The 1905 Aliens Act was introduced following concerns about overcrowding in East London and the impact of newly arrived Eastern European émigrés on the established Jewish community. It controlled entry at Britain's ports and required immigrants to provide evidence that they could support themselves.[4] Responses to the works of Jewish artists, and debates about whether Jewish art constituted a distinct school or genre, thus took place within this political context and wider debates about Jewish identity and assimilation.

Rothenstein's German parents had immigrated to Britain in 1859, and his father was a prosperous wool merchant. Born in Bradford, Rothenstein had trained at the Slade School of Fine Art and then in Paris before becoming a leading member of the New English Art Club. In *Mother and Child* 1903 (fig.29) Rothenstein depicted his wife and son in their Hampstead home, demonstrating his social status and artistic allegiances. The cool restricted palette and the figure seated in profile were strongly influenced by the work of James McNeill Whistler, and Rothenstein also used carefully selected artworks and ornaments to convey his refined aesthetic taste. In the same year he visited the Spitalfields synagogue for the first time and subsequently produced several works inspired by Jewish religious ceremony.[5] *Jews Mourning in a Synagogue* 1906 (fig.30) was shown at the *Jewish Art and Antiquities* exhibition held at the Whitechapel Art Gallery in 1906, alongside works by Solomon J. Solomon, Camille Pissarro and Alfred Wolmark, among others.[6] It has been argued that this exhibition aimed to promote Jewish assimilation in the aftermath of the Aliens Act, displaying a form of Jewishness consistent with English middle-class social and moral values. The exhibition, like Rothenstein's painting, focused on religion as the bedrock of Jewish identity, and emphasised the ways in which its spiritual and moral values permeated the home, while ignoring Yiddish language and popular culture.[7] The catalogue dismissed the idea of a Jewish art that was distinctive in style, observing that the majority of Jewish artists, 'identifying themselves entirely with their adopted country after the manner of the Jewish people, alike in feeling and in subject, show no trace of distinctive thought or differentiation of artistic sentiment'. It was drawing on assimilationist discourse in asserting that Jewish artists would contribute to

the success of the national school instead of creating a distinctive Jewish identity within it.[8]

Rothenstein was an adviser to the Jewish Education Aid Society (JEAS), which gave grants towards higher education for Jewish children. In the early twentieth century the society's financial support allowed young artists, including Mark Gertler, David Bomberg, Isaac Rosenberg and Jacob Kramer, to study at the Slade School of Fine Art. Mark Gertler was the son of Austrian-Polish émigrés who worked in the fur trade in Spitalfields. After studying at the Slade, supported by the JEAS, between 1908 and 1912, he became close to the writers and artists of the Bloomsbury circle. Although Gertler was never a core member of the group he shared an interest in post-impressionism with Roger Fry; the contrast between the modest family background that provided the material for much of his early work and the social milieu of this elite circle would prove a source of tension throughout his life.[9] The interplay between these two worlds is articulated through a series of portraits of his mother. In 1911 Gertler used the classic mode of Slade realist portraiture to depict his mother as a middle-class Edwardian matron (*The Artist's Mother* 1911, fig.31). She is dressed for a studio portrait, wearing a black silk dress ornamented at the neck with an elaborate brooch and collar, although her strong hands are those of a working woman. But two years later, in 1913, he used simplified forms, which drew on the influence of folk art and the Italian primitives, to portray her as an Eastern European peasant dressed in a headscarf and plain blouse and skirt in *The Artist's Mother* 1913 (Glyn Vivian Art Gallery, Swansea). She appears again in this costume in Gertler's *Jewish Family* 1913 (fig.32). Gertler's letters reveal his commitment to realism and his ambivalence about the rhetoric of modernism and its competing factions,[10] so it is possible to interpret Gertler's new use of primitivist source material as a search for a more 'authentic' visual language with which to

depict everyday Jewish subject matter. However, this is problematic, because it not only aligns Gertler's work with nineteenth-century stereotypes of working class Jewish culture as archaic and uncivilised, but also ignores the complex ways in which subject matter and aesthetics were intertwined in Gertler's work, and the impact on his work of his negotiation of two very different social environments.[11] Primitivism was a primary source of inspiration for post-impressionism and explored by the Bloomsbury artists and other modernist groups in London, so his use of the idiom also explicitly aligned him with developments in avant-garde British art.

David Bomberg, the son of a Polish Jewish leatherworker, was supported by the JEAS while studying at the Slade between 1911 and 1913. In 1913 Bomberg was invited to select work for a 'Jewish Section' in the exhibition *The Twentieth Century: A Review of Modern Movements* held at the Whitechapel Art Gallery from May to June 1914. This exhibition aimed to review the parallel strands of modernism in British art since 1910.[12] The 'Jewish Section' was the only part of the exhibition to be grouped by ethnicity rather than style, and art historians have debated the extent to which this allowed Jewish artists to define a distinctive identity for themselves or if it merely echoed the marginalisation of Jewish communities within British society.[13] Bomberg worked on the selection with Jacob Epstein, the American sculptor also of Polish Jewish origin, who had arrived in Britain in 1905.[14] The work exhibited was varied in style and subject matter, ranging from Alfred Wolmark's Fauve-inspired *Decorative Still Life* c.1911 (Tate) to Gertler's neo-primitive *Jewish Family,* and to Bomberg's geometric figure composition *Vision of Ezekiel* 1912 (Tate). Epstein's portrait bust of *Euphemia Lamb* 1908 (fig.33), inspired by Renaissance sculpture busts, although not included in the 'Jewish Section' itself, was displayed at the entrance to the room.[15]

Bomberg evidently saw the 'Jewish Section' as an opportunity to define a modern Jewish school of painting, and in an interview in the *Jewish Chronicle* he stated: 'It may be anticipated that the school will gain many new recruits and the exhibition at Whitechapel will show the public what is being done in this genre by Jewish artists'.[16] But Bomberg's definition of this 'school' or 'genre' was very different from the concept of Jewish art presented by the Whitechapel exhibition of 1906. Rather than showing how Jewish art was indistinguishable from mainstream British art, Bomberg's selection focused on artists who were both Jewish and whose work was compatible with avant-garde developments in British art, thereby aiming to stake out a distinct visual identity for modern Jewish art.[17] Bomberg's strategy was certainly successful in establishing a connection between Jewish artists and modernism in the public eye, although the reviewers' reactions to the 'cubist' works were primarily hostile.[18]

The *Jewish Chronicle* devoted the whole of its review of the exhibition to the 'Jewish Section', regretting the exclusion of older artists such as Rothenstein and criticising Bomberg's paintings, such as *Vision of Ezekiel*, which were 'merely a waste of good pigment, canvas and wall space ... hurtful to our reason and commonsense', and which failed to achieve his 'desires to convey in his work the energy and movement of a century of machinery and wireless technology'. However, Gertler's *Jewish Family* was praised for 'its real psychological insight and feeling', and was judged to have succeeded in conveying 'an inexpressible sense of homeliness'.[19] Other reviewers noted the consciously archaic nature of Gertler's figures – comparing the seated man to 'a gargoyle' or 'figures in medieval woodcarvings' – and characterised his art as a 'proper development of the realist art of the nineteenth century', imbued with 'vitality and vivid personal expression', belonging to the 'world of flesh and blood' rather than the 'world ... of abstract geometrical designs'.[20]

Although Gertler's monumental figures and the stark setting created a mythical and archetypal version of the Jewish family, the painting's apparent humanist concerns were still seen as broadly compatible with traditional discourses of the Jewish family and the celebration of domestic life within the Jewish community, in contrast to the mechanical and impersonal associations of Bomberg's geometric forms.[21]

Bomberg's *The Mud Bath* 1914 (fig.34) was not included in the Whitechapel exhibition, but formed the centrepiece of his solo exhibition at the Chenil Gallery in July 1914. The painting depicts the Russian Vapour Baths in Whitechapel, used by the Jewish population for socialising and purification, and is perhaps Bomberg's strongest expression of how the depiction of modern Jewish urban life might be combined with the search for pure form. He wrote in the foreword to the catalogue, 'In some of the work I show in the first room, I completely abandon *Naturalism* and Tradition. I am *searching for an Intenser* expression. In other work in this room, where I use Naturalistic Form, I have *stripped it of all* irrelevant matter.'[22] Bomberg represents the pool as a red rectangle with simplified blue and white figures climbing in and out of it, evoking the colours of the Union Jack. This association seems to have been intentional, as the painting was hung outside the gallery surrounded by flags, and at least one reviewer commented on this juxtaposition.[23] This fragmented British flag has been read as a comment on British jingoism in the prelude to the First World War, but it is also emblematic of the fragmented British identity of the younger generation of Jewish émigré artists in this period, with their allegiances to two worlds: the Jewish East End of their families, which provided vital subjects for their art, and the avant-garde circles in which they needed to establish their artistic reputations.

Emma Chambers

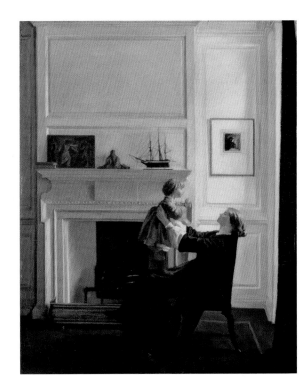

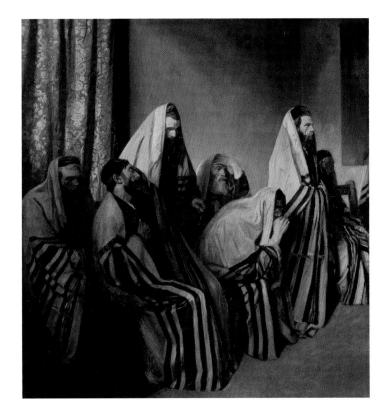

29 William Rothenstein (1872–1945) *Mother and Child* 1903. Oil paint on canvas 96.9 × 76.5
30 William Rothenstein (1872–1945) *Jews Mourning in a Synagogue* 1906. Oil paint on canvas 127.5 × 115.5

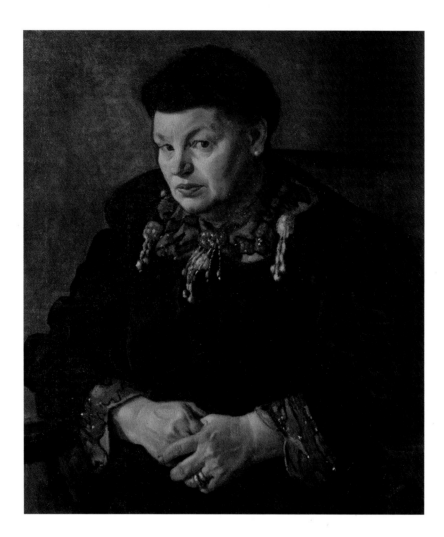

31 Mark Gertler (1891–1939) *The Artist's Mother* 1911. Oil paint on canvas 66 × 55.9

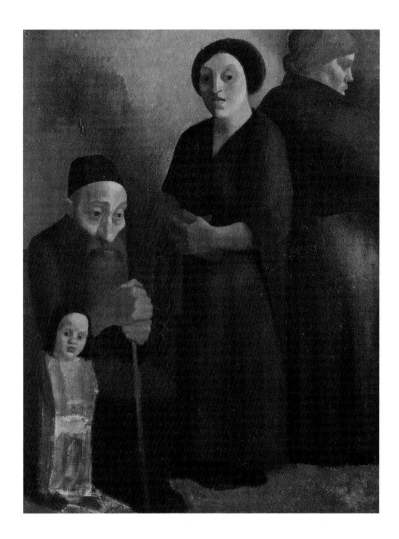

32　Mark Gertler (1891–1939) *Jewish Family* 1913. Oil paint on canvas 66 × 50.8

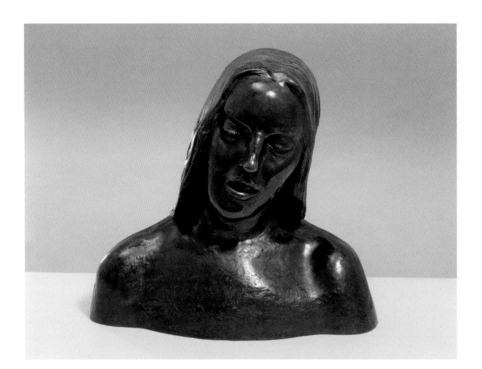

33 Jacob Epstein (1880–1959) *Euphemia Lamb* 1908. Bronze 37.5 × 40 × 20.3

34 David Bomberg (1890–1957) *The Mud Bath* 1914. Oil paint on canvas 152.4 × 224.2

Refugees from Nazi Europe

In the 1930s and 1940s a significant number of artists fled to Britain, escaping political unrest and war in Europe. Hitler's accession to power in 1933 and the religious and racial discrimination enshrined in the Nuremberg Laws from 1935 prompted the first wave of immigration, and the flow of refugees intensified in 1938 with the annexation of Austria and increased persecution of Jews.[1] Artists became refugees for different reasons, many were Jewish and had left to escape persecution, others had been outspoken political opponents of fascism, still others left voluntarily, finding dwindling opportunities for pursuing avant-garde art under the strict cultural controls imposed by the Nazi government. And the Nazi's *Entartete Kunst* exhibition in Munich in 1937 condemned many avant-garde artists' work as 'degenerate', providing another impetus for flight.[2]

Once in Britain, establishing new support networks was vital. British avant-garde circles centred on Hampstead, and later Cornwall, provided support for architects and artists such as Walter Gropius, Marcel Breuer, Naum Gabo, Laszlo Moholy-Nagy and Piet Mondrian.[3] For others such as Oskar Kokoschka, Jankel Adler, Hans Feibusch and Peter Peri, artists' associations such as the left-wing Artists International Association (AIA) and émigré societies such as the Free German League of Culture (FGLC) provided a focus, British contacts and opportunities to exhibit.[4]

European émigrés had a significant impact on British graphic design and architecture, bringing German and Central European modernist principles of design to Britain.[5] The Hungarian artist Moholy-Nagy had worked in Germany for much of his career, including with Gropius at the Bauhaus between 1923 and 1928, but had existing contacts with British avant-garde circles through the European group of abstract artists Abstraction-Création.[6] Moholy-Nagy's work had ranged widely across painting, photography and design and this varied experience proved invaluable in establishing himself in Britain. He arrived in May 1935 and showed his work alongside British artists in the exhibition *Abstract & Concrete* in 1936, at the Lefevre Gallery in London and touring to Liverpool, Oxford and Cambridge, the *Constructive Art* exhibition at the London Gallery in 1937, the third AIA exhibition in 1937, and had a solo show at the London Gallery in December 1936. Alongside his fine-art projects he worked as art director for the magazine *International Textiles*, took on commercial design commissions for Imperial Airways and London Transport and secured a position as director of window displays and interiors at Simpson's Piccadilly.[7] He also unsuccessfully investigated setting up an English Bauhaus with Gropius, who had moved to London in 1934.[8] After Gropius's move to America in 1937 to take up a teaching post at Harvard, Moholy-Nagy was encouraged to emigrate once more to set up a new Bauhaus in America. He left London in July 1937 for Chicago, where the New Bauhaus was established in November 1937.

In 1932 Gabo had moved from Berlin to Paris, partly prompted by the deteriorating political situation in Germany. He too was a member of Abstraction-Création and was also invited to exhibit in *Abstract & Concrete* in 1936. This invitation helped to consolidate Gabo's existing links with the British avant-garde and created an impetus for his move to London in March 1936.[9] As a major European artist in exile, Gabo received considerable attention and recognition, and his presence in Britain was an important catalyst for British constructivism.[10] Friendships with artists Ben Nicholson and Barbara Hepworth, the art critic Herbert Read and the architect Leslie Martin, with whom he shared a commitment to the social responsibility of abstract art, led to the formation

of the avant-garde periodical *Circle* and Gabo's participation in the *Constructive Art* exhibition in London in 1937.[11]

Britain also had an impact on Gabo's work. He became interested in concepts, such as 'truth to materials', that were current among British sculptors.[12] Through contacts with the chemical company ICI he became aware of new materials such as Perspex and nylon thread, used to great impact in works such as *Construction in Space with Crystalline Centre* 1938–40 and *Linear Construction No.1* 1942–3 (both Tate). *Linear Construction* was Gabo's first work to employ the technique of linear stringing, inspired both by mathematical models and by the British textile industry.[13] Gabo also took on commercial projects, including a commission in 1943 from the Design Research Unit, led by Herbert Read, to design a car for Jowett Cars, although this was never manufactured.[14] Gabo had moved to Cornwall with Nicholson and Hepworth during the war, but suffered considerable financial hardship, and in 1946 he began to investigate the opportunities that America offered. In November 1946 he travelled to New York to discuss an exhibition of his work at the Museum of Modern Art, and remained there for the rest of his life.

Mondrian had corresponded regularly with Nicholson from April 1934, but their discussions shifted from their work to the political situation in Europe and the practicalities of emigration, as Mondrian made plans to leave Paris in September 1938.[15] Nicholson and Hepworth helped him to find a studio close to theirs, and he immediately painted its walls and furniture white, affixing cards painted in primary colours to the wall.[16] This provided him with a settled and familiar environment where he could think through ideas and compositions. Initially his health was poor and he was unable to paint, but by February 1940 he told Nicholson that 'I began a new composition (small) ... but mostly I am trying to get the old pictures better'.[17] One of the works he may have been working on was *Composition with Yellow, Blue and Red* 1937–42 (fig.36), which charts Mondrian's movements between Paris, London and New York through its evolving composition. This work was begun in Paris and is structured by the strong verticals and ladder effect that he was developing there in the late 1930s, but was completed in New York, where the short strips of unbounded colour, which first appear in his New York paintings, were added.[18] By October 1940, unsettled by the Blitz, he had moved to New York and was establishing himself there, although he felt nostalgic for London. He wrote to John Cecil Stephenson: 'I do like New-York but in London I was of course more at home.'[19]

Kokoschka had emigrated from Austria to Czechoslovakia in 1934 and arrived in London on a Czech passport in October 1938. Nineteen of his works, including his *Self-Portrait of a 'Degenerate Artist'* 1937 (private collection on loan to the Scottish National Gallery of Modern Art), were included in the *Exhibition of Twentieth-Century German Art* in London in July and August 1938. Organised by Herbert Read, this exhibition was intended as a riposte to the 1937 *Entartete Kunst* exhibition (in which Kokoshchka's work had featured prominently), but was compromised in this aim by its exclusive focus on the issue of artistic freedom while avoiding political comment.[20]

Although Britain provided a safe haven for artists from many European countries in the 1930s, this welcome was short-lived for German and Austrian refugees. In June 1940 the British government decided to intern all Germans and Austrians currently in the country, which included many artists who had fled to Britain to escape the Nazis. The Artists Refugee Committee, which had been formed in 1938 to help artists escape from Nazi Europe, now played a key role in petitioning for their release.[21] Public pressure led to the reversal of the policy of internment, with the majority of internees released in 1941.[22] With his Czech passport, Kokoschka escaped internment, but was forced to return to London from Cornwall,

where he had been living since 1939, by the ban on foreigners residing in coastal areas. Here he was active in anti-Nazi refugee organisations such as the Free Austrian Movement and the FGLC and exhibited in the AIA's *For Liberty* exhibition in 1943.[23] In London Kokoschka's work became increasingly politicised. *The Crab* 1939–40 (fig.38) was begun in Cornwall as a naturalistic landscape showing the view from the terrace of his cottage in Polperro, but was reworked in London to directly address the British policy of appeasement towards Germany and the part this played in the gradual German occupation of Czechoslovakia between September 1938 and March 1939. Kokoschka described how the menacing crab dominating the foreground represented Neville Chamberlain and the small swimmer Czechoslovakia; the crab 'would only have to put out one claw to save him from drowning, but remains aloof'.[24]

The Polish artist Jankel Adler was unusual among émigré artists in experiencing the Second World War as a soldier. Adler studied in Germany and established a career in Düsseldorf. Both Jewish and a political activist, he left for France in 1933 after the Nazis came to power.[25] Adler joined the Polish army at the outbreak of war, but was discharged for poor health in 1941. He settled in Scotland, moving to London in 1943. *The Mutilated* 1942 (fig.37) directly addresses the brutal impact of war in human terms and was exhibited at Adler's solo exhibition at the Redfern Gallery in 1943.[26]

Many artists adapted their work to respond to the conditions of exile: Moholy-Nagy focused primarily on design work during his time in Britain, Mondrian's slow working practice meant that paintings bore the imprint of different cities and Gabo's repeated moves from Russia to Germany, France and Britain meant that he had developed a migratory practice where he transported ideas for sculpture in the form of small model versions, which could be realised when he settled.[27] Experiences of flight and exile were visible in the subject matter and materials of other artists'

work. Marie-Louise von Motesiczky travelled to Britain via Amsterdam, leaving Vienna with her mother the day after the annexation of Austria by Germany on 12 March 1938. Living temporarily in a hotel in Amsterdam, she painted a still life of objects arranged on an ironing board in her hotel room. The Chinese cloisonné sheep in *Still Life with Sheep* 1938 (fig.40) were family heirlooms brought from Vienna and poignantly emblematic of home and the attempt to establish it briefly in an unfamiliar place.[28] Kurt Schwitters's *Picture of Spatial Growths – Picture with Two Small Dogs* 1920–39 (fig.35) embodies the process of flight in the materials used to construct it. The collage was begun in Germany using German printed materials and ephemera, which were overlaid with Norwegian ones when Schwitters fled to Norway after his work was included in the *Entartete Kunst* exhibition in 1937. He travelled to Britain in 1940 following the German invasion of Norway, leaving behind the majority of his possessions, and the work itself remained in Norway until after the war.

After peace was declared a few émigré artists returned to Europe, but the majority remained in Britain and became British citizens. Exhibiting and obtaining teaching posts, they gradually became redefined as British artists and influenced a new generation. Tellingly, the commissions for the Festival of Britain in 1951 included a significant number of scenes of British life by émigré artists including Siegfried Charoux, Peter Peri and Josef Herman.[29]

Emma Chambers

35 Kurt Schwitters (1887–1948) *Picture of Spatial Growths – Picture with Two Small Dogs* 1920–39.
Mixed media collage on board 115.5 × 86.3 × 13.1

36 Piet Mondrian (1872–1944) *Composition with Yellow, Blue and Red* 1937–42. Oil paint on canvas 72.7 × 69.2
© 2012 Mondrian/Holtzman Trust c/o HCR International Washington DC

37 Jankel Adler (1895–1949) *The Mutilated* 1942–3. Oil paint on canvas 86.4 × 111.8
38 Oskar Kokoschka (1886–1980) *The Crab* 1939–40. Oil paint on canvas 63.4 × 76.2

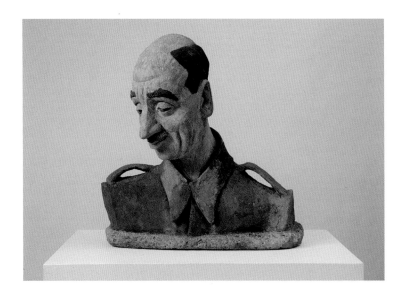

39 Peter Peri (1899–1967) *Mr Collins from the A.R.P.* 1940. Pigmented concrete 67.5 × 68 × 40
40 Marie-Louise von Motesiczsky (1906–1996) *Still Life with Sheep* 1938. Oil paint on canvas 40 × 80.5

41 Hans Feibusch (1898–1998) 1939 1939. Oil paint on wood 152.4 × 91.4

Artists in Pursuit of an International Language

By the 1950s Britain was experiencing continuous mass immigration. Since the arrival of the *Empire Windrush* at Tilbury in London in 1948, the influx of men and women from Africa, Asia and the Caribbean had increased, along with racial tension. Despite an official reluctance to allow immigration from the diminishing empire, there was still a need to expand the labour workforce following the devastation of the Second World War, and the country was forced to look beyond European borders. Many of these migrants spoke English well and had been raised to revere the British Empire; they were being offered work in a country that they considered their own, but on arrival were less welcomed than anticipated. Struggle, adaptation and confrontation became part of the migratory process, while their arrival shifted the cultural balance in a predominantly white society.

London in particular was in a state of flux. While bombsites were still dominant features of the cityscape, there was also a sense of relief that the war had ended; there was widespread optimism for a better future of wealth and liberation. New groups of artists, such as the Independent Group, who met at the Institute of Contemporary Arts in London between 1952 and 1955, reflected on and became part of a scene defined by a burgeoning popular culture that also embraced fashion designers, photographers and pop musicians.

A number of artists from the newly independent British colonies came to study in a range of academic fields. Others came because they were frustrated by the lack of criticality and internationalism in their art institutions at home; many artists moved to London because they were seduced by the spreading language of modernism. Artists such as F.N. Souza, Avinash Chandra, Anwar Jalal Shemza and Iqbal Geoffrey had already established careers in their home countries, but on arrival found it difficult to break into the art scene, being instead sidelined and viewed solely in terms of their ethnicity rather than their artistic output. Even though the term 'internationalism' became a buzzword in London during the 1950s and 1960s, most of these artists were often restricted to exhibiting in the Commonwealth Institute. There were, however, a handful of commercial galleries that showed works by artists from the Commonwealth alongside artists from Europe and America – these included Signals London, Indica Gallery and Gallery One, which exhibited Souza, Shemza and Chandra. The New Vision Centre, set up by the South African artist Denis Bowen and Kenneth Coutt-Smith, showed over 220 international artists, including Aubrey Williams, between 1955 and 1966.

Souza and Chandra enjoyed much success during the mid-1950s and early 1960s, but while their practices were concerned with different themes, they were both seen as 'exotic'. Souza grew up as a strict Catholic in Goa and his work often evoked the feelings of religious and cultural conflict that he was experiencing (fig.42). Chandra's paintings were deeply rooted in his Indian heritage but also revealed his admiration of van Gogh and Soutine (fig.43). Due to a general lack of integration with the London art world, many of the galleries showing their work were forced to shut down by the late 1960s, making recognition by the art establishment an even more unrealistic ambition. Interest in the Commonwealth started to fade in the late 1960s as Britain was increasingly aligning itself politically, economically and culturally with America, and, in the art world, the focus had shifted from American abstract expressionism to pop art. During this time some artists, including Souza and Frank Bowling, found it necessary to leave Britain for New York to pursue their careers.

The notion of displacement functioned as a fertile ground for some artists, such as Shemza who had experienced a revelation during an art history lesson at the Slade School of Fine Art when his tutor dismissed Islamic art as purely functional and decorative. Shemza recalled how he destroyed all his paintings, which were figurative at the time, and started to explore his own cultural history at the British Museum and the Victoria and Albert Museum. His practice consequently developed into compositional schemas as deeply influenced by Western modernists such as Paul Klee as by Arabic and Persian calligraphy and Islamic motives and design (fig.44).

Similar concerns around memory, place and displacement can be found in the early works of Frank Bowling and Aubrey Williams. While colour is the fundamental ingredient of Bowling's luscious paintings, the iconography he started to incorporate in the early 1960s – the image of his mother's grocery store in British Guyana, for instance – indicated the importance of personal memory in the formation of his artistic language, while the inclusion of maps of Guyana in later paintings reveal an engagement with a more political subject matter (fig.45). Williams's subject matter was deeply rooted in memories of his early life in Guyana. The artist had trained as an agronomist and his work took him to the Guyana rainforest, where he lived for two years among the indigenous Warrau people. This, combined with witnessing political change in his home country and the influence of Arshile Gorky's work, deeply affected his visual vocabulary (fig.46). He exhibited widely and enjoyed much commercial success, including several well-received shows at the New Vision Centre; however, as it had for other artists from the Commonwealth, the interest in his work had diminished by the mid-1960s. A lack of criticality in understanding his works prompted him to join the Caribbean Artists Movement (1966–72), along with the sculptor Ronald Moody, an influential

writers' movement within black visual and literary culture of the time. CAM was formed to raise the profile of West Indian art within Britain, but also to revive their art forms and to develop an independent cultural identity for black people.

The pluralities of modernism and modernity became distinct and palpable during these two decades in Britain. Artists such as Li Yuan-chia and Kim Lim made an important contribution to British art history by fusing far Eastern and Western philosophies and art practices. Yuan-chia had studied and practiced calligraphy and was considered one of the founding figures of abstraction in Taiwan before he arrived in Britain, applying the language of abstraction to existential conditions. Yuan-chia's most personal visual mark is a singular point or a circular form, which is found throughout his work and symbolises the beginning and the end of all things. In the late 1960s Yuan-chia decided to leave London and, with the support of the artist Winifred Nicholson, set up the LYC Museum and Art Gallery in 1972 in Cumbria. The small farm conversion housed an art gallery, library, theatre, printing press and children's art room and exhibited more than three hundred artists between 1972 and 1983, becoming a major attraction for local residents and tourists. Lim's practice, meanwhile, was acutely informed by her constant travels and, in particular, trips to her native Singapore. For Lim, exposure to archaic sculpture uncovered new possibilities: particularly taken by the directness, simplicity, symbolism and impact of these sculptures, she applied a similar sense of organic rhythm, light and repetition to her own works.

Rasheed Araeen, who had studied to become a civil engineer in Karachi, was deeply inspired by modernism, which he wished to experience firsthand by coming to Europe. After a short stint in Paris Araeen moved to London in 1964, where he was struck by British sculpture, and the works of Anthony Caro in particular, whose straightforward employment of industrial materials

appealed to Araeen's civil engineering sensibili-
ties. While still working as an engineer in London,
Araeen made *Drawing for Sculpture 1965*, works on
paper that were to be the origin of his key mini-
malist sculptures such as *Sculpture No.1 1965*. These
revealed the influence of the constructivists on his
oeuvre, as was later explored in works such as *Rang
Baranga 1969* (fig.47). Araeen's work received no
institutional recognition until later in his career,
and he was mostly relegated to and understood in
the context of postcolonialism, rather than for his
contributions to the modernist discourse. This led
to the politicisation of his work as an artist, writer
and curator. In 1972 he became a member of the
Black Panther Movement in London and six years
later he founded and edited *Black Phoenix*, which
later transformed into the quarterly publication
Third Text. Araeen curated many important exhibi-
tions, among which *The Other Story: Afro-Asian Artists
in Post-war Britain* at the Hayward Gallery, London,
in 1989 stands as a crucial benchmark. For the
first time debates around postcolonialism and
diaspora were apparent through the inclusion
of artists who had moved to Britain but whose
work had never been critically evaluated within
the art establishment.

Over the last twenty years there have been
many debates addressing the lack of integration
of these artists into the fabric of British art. These
discourses have confirmed their substantial contri-
bution to this history, but also allow us to move on
and look at the work in a different light. Not only
has assimilation and confrontation informed the
practice of these artists: the circumstances of move-
ment itself inevitably produces dual identities in
a divided artworld. The segregation forced upon
artists encouraged them to define an individual
language so that their practices were enriched by
relocation, allowing them to innovate and redefine
ideas of modernism, and question its perception
as a solely Euro-American phenomenon.

Leyla Fakhr

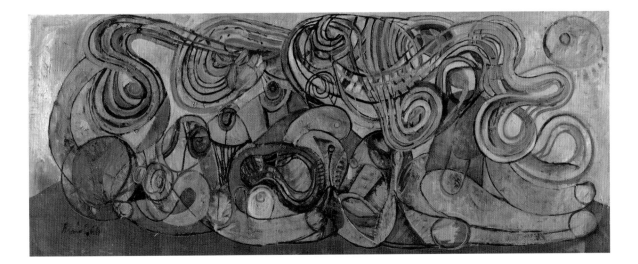

42 F.N. Souza (1924–2002) *Crucifixion* 1959. Oil paint on board 183.1 × 122
43 Avinash Chandra (1931–1991) *Hills of Gold* 1964. Oil paint on canvas 101.6 × 241.3

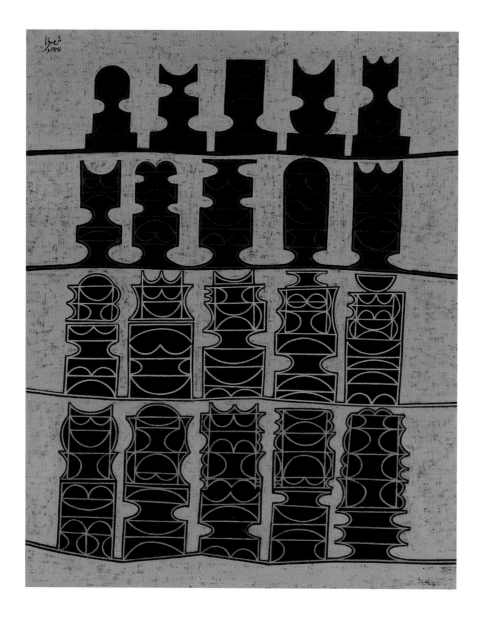

44 Anwar Jalal Shemza (1928–1985) *Chessmen One* 1961. Oil paint on canvas 92 × 71

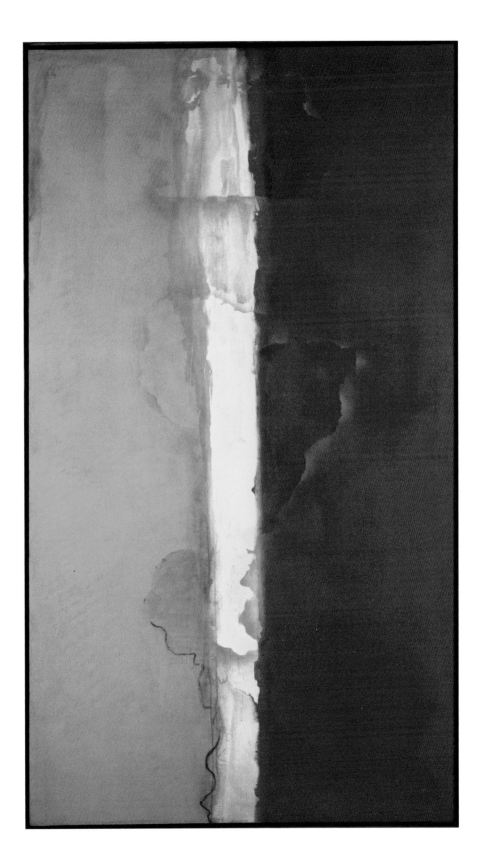

45 Frank Bowling (born 1936) *Who's Afraid of Barney Newman* 1968. Acrylic paint on canvas 236.4 × 129.5

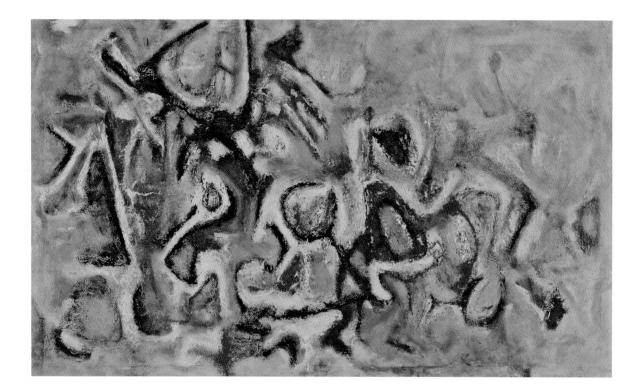

46 Aubrey Williams (1926–1990) *Death and the Conquistador* 1959. Oil paint on canvas 83 × 134

47 Rasheed Araeen (born 1935) *Rang Baranga* 1969. Wood and paint 182 × 61 × 46

The Stateless Artist

Buried within the folds of a rich tapestry of post-war artistic practice, which included such diverse trends as pop art and minimalism, existed a counterculture in Britain that was, and is, often overlooked. Artists who worked within this subculture were attempting to achieve many things in their work, but above all they engaged with the idea of dematerialisation, where the art object was no longer a stable entity that fitted neatly into museum spaces, but rather had a life of its own. The artworks were ephemeral by nature, constantly in flux through shifts and changes in their physical make-up. One key artist, David Medalla, captures this immediacy and transience: freedom is not only a feature of his work, but also a fundamental trait of the way he lives his life. Medalla spends lengthy periods in Britain, but does not align himself with any particular country, and is therefore liberated from the notional terms of 'nation' or 'identity'. His identity is his own, and, like his work, is fluid.

After the Second World War Europe and the United States were anxious to reinforce a sense of national identity to combat the ideological and cultural battle that had dominated the preceding years. In the 1950s and early 1960s Britain in particular, contending with the remnants of a once-dominant empire, emphasised the significance of place. London was the most obvious place to be, and during this period floods of people came from abroad, as well as from other parts of the UK, drawn not only by the promise of financial stability, but also by the idea that London itself was the centre of the world.

Not long after this period, and in an attempt to refute its inherent limitations, artists such as Medalla, Gustav Metzger and David Lamelas, among others, contested the idea of national borders. This is not to say they rejected the cultural idiosyncrasies of different peoples, but rather asserted their equality within the complex web of human culture as a whole. This idea can be seen across various cultural practices, but artists played a key role in the attempt to resist a fixed identity. As a result it was, and still is, a complex task to define and categorise them. This is also true of their art, since the object is no longer a solid entity, but fragmented into multitudinous matter and meanings. And it is perhaps because of the works' ephemerality and changeability that these artists have remained marginal to the mainstream history of British art, despite their important contribution to it.

Metzger was sent to Britain from Germany with his brother when war broke out in Europe in 1939. This period of dislocation has continually informed his practice, not simply in the political themes he engages with, but also in his examination of a universal cyclical movement of destruction and creation: from the act of destruction emerges a new creation. He explored this in the seminal Destruction in Art Symposium (DIAS) in 1966, when artists, philosophers, academics, critics and others gathered to probe the notion of a new type of art that applied these ideas to processes rather than simply taking them as subject matter. Metzger had experimented with this previously in his public demonstrations of auto-destructive art, a term he coined in the early 1960s. On London's South Bank in 1961, for example, he sprayed acid onto stretched nylon and, as it touched the surface, the material began to disintegrate, revealing the iconic St Paul's Cathedral on the other side of the river (fig.48). Clad in the costume of war, with gas mask, goggles, gauntlets and combat jacket, Metzger appeared as though about to enter into battle – an image that, coupled with the rather brutal collapse of the material, was suggestive of the recent horrors across Europe. And yet there was a rather poetic aesthetic to

this destruction, where materiality gave way to immateriality, a process that itself carries nuances of creation. That St Paul's Cathedral was framed by this performance not only recalled the damage and rebuilding of London during this period, but, more importantly, enforced the comparable material weightiness of the historic building in contrast to the temporality of the event. Through the act of destruction and reveal Metzger implied the transience of human nature and asserted the widespread desire to transcend the limitations of the physical.

Lamelas first arrived in Europe in 1968 to represent his native Argentina in the Venice Biennale, and in the same year travelled to London to begin a scholarship at St Martin's School of Art, as well as to work on *A Study of Relationships Between Inner and Outer Space* for Camden Arts Centre (fig.49). The film studies the gallery space in intricate detail, and then moves outwards to discover the contextualising surroundings of London; it then pulls out further still, positioning the gallery within the world and universe through interviews with Londoners about the recent NASA rocket launch to the moon. Within and between this network of places and spaces exists the multifarious transmission and exchange of information that keeps the network alive: the blueprint for a living organism, or an entire universe. Context itself is very important, and Lamelas has described his move to London as based on 'the diversity of what was taking place, the sense of freedom'.[1] However, while interested in specific locations, he is never limited in his conceptualisation of them, instead wishing to position them within a wider universal parameter, allowing for constant shifts in perception that acknowledge the expanse of time and space. The work is therefore no longer an autonomous entity, but relies intrinsically on the world around it.

This desire to make connections between one's immediate physical surroundings and the wider world was certainly in keeping with fellow artists Metzger and Medalla. Medalla has achieved a state of being that is unburdened by place, and has been described as a 'transnational nomad'.[2] Born in the Philippines, he has travelled extensively across Asia, Europe, Africa and the Americas. This kinaesthesia allows him a fluid identity, and he encourages a vision of the world that is composed of numerous interconnected webs that proliferate across the globe. Through his spur-of-the-moment public performances, or 'impromptus', he kindles these bonds, creating dialogues between people, places, stories and objects. Due to the fact that they are often performed spontaneously and outside the context of the art world, there are few visual records. These 'random and chance events of existence' often subsist simply in the memories of those involved.[3] In keeping with this exploration of the fleeting, the momentary, Medalla's *Cloud Canyons* series 1963–2004 (fig.50) comprises machines that continually spout sinuous towers of foam, collapsing before rebuilding themselves anew. Metzger himself referred to Medalla as 'the first master of auto-creative art', as he challenges the concept of the static sculpture through a continual cycle of destruction and renewal; its physicality ruptures and is transformed into something less rooted in the material world.[4]

As well as establishing the groups Exploding Galaxy, an international organisation of counter-cultural artists working in a multi-media format, and Artists for Democracy, which was committed to providing support to liberation movements worldwide through artistic and cultural projects, Medalla co-founded the Centre for Advanced Creative Study with Gustav Metzger, Paul Keeler, Marcelo Salvadori, Christopher Walker and Guy Brett in 1964. Its raison d'être was to experiment creatively with avant-garde notions of kinetic and optical art, and to forge a relationship between physics and aesthetics. From this sprung the gallery Signals London (with an accompanying news bulletin), an interdisciplinary and cosmopolitan space, showing artists such as Lygia Clark,

Li Yuan-chia, Liliane Lijn and Vassilakis Takis, among others, and introducing many of them to a London audience for the first time.

Much of the work that Medalla, Metzger and Lamelas produced during this period was ephemeral and existed in a multiplicity of forms. They favoured experimentation over perpetuity, resulting in works with limited life spans, and as such these posed, and continue to pose, numerous challenges to museums like Tate, whose collections largely comprise physical objects. But that some of these original works have been reconceptualised – remade, reperformed, retranslated or reconfigured – has enabled younger generations to continue to be influenced by work that is unrestricted by the limits of material or location.

Lena Mohamed

48 Gustav Metzger (born 1926) demonstates his *Auto-Destructive Art* at the South Bank, London, 3 July 1961

49 David Lamelas (born 1946) *A Study of Relationships Between Inner and Outer Space* 1969
Film, 16mm, black and white, and sound, 20 min. Courtesy David Lamelas and LUX, London

50 David Medalla (born 1942) *Cloud Canyons* 1963. Mixed media, dimensions variable (Photographs by Clay Perry c.1964, courtesy England & Co., London)

Mobility in Contemporary Art T.J. Demos

Consider the following artworks: Mona Hatoum's *Measures of Distance* 1988, a video made during Lebanon's civil war that reflects upon the desired but interrupted intimacy between the London-based artist and her Lebanese-Palestinian mother living in Beirut (fig.55 on p.96); Isaac Julien's film *Territories* 1984, which mediates postcolonial subjectivity (that of British Afro-Caribbean-ness) in the context of London's Notting Hill Carnival by opening up its political fissures through the disjunctive textures of cinematic palimpsests (fig.51); and Black Audio Film Collective's *Handsworth Songs* 1986, a film that deploys hybrid representations, both documentary and poetic, to reveal the diversity of local perspectives on the early 1980s race riots against the repressive police measures in the working-class and migrant-populated area of Birmingham (fig.53 on p.95). These pieces variously demonstrate a powerful intertwining of the social and political facts of diaspora and exile with the aesthetics of dislocation and fragmentation, which distinguishes black British practices in the 1980s.

It is with that decade that I'll begin my inquiry into forms of mobility and migration in contemporary art, which I will group loosely around three formations: the diasporic aesthetics of the postcolonial in Britain during the 1980s; the post-socialist decade of triumphalist neoliberal globalisation during the 1990s; and the post-2001 era marked by increased anxieties over migration and refugees in the context of the so-called 'War on Terror', the political-economic instability in the Global South and the growing threat of climate change. This periodisation is not meant as punctual or neatly chronological; rather it is meant to offer a genealogy of art practices with overlaps and disjunctions, gauged in relation to the various ways artists have taken up mobility as form and structure, as well as subject and politics, in contemporary art.

Considering the way Hatoum has directed her experience of geopolitical displacement into a post-minimalist sculptural phenomenology of disjointed everyday spaces and uncanny domestic objects, Edward Said writes insightfully about how in her work 'exile [is] figured and plotted'. Born into a displaced Palestinian family in Beirut, she was studying art in London and found herself stranded there when the Lebanese civil war broke out in 1975. That experience informs her practice. By enacting 'the paradox of dispossession as it takes possession of its place in the world', Said writes, Hatoum's projects draw out the 'irreconcilability' of strangeness and familiarity that defines the experience of living away from one's homeland.[1] Said's reading bears directly on *Measures of Distance*, which shows Hatoum's mother in the intimacy of her shower, while reproduced handwritten Arabic fragments of her correspondence with

her daughter form a barrier over the image, expressing simultaneously the painful distance and the longings for closeness that mark the artist's experience. Kobena Mercer focuses similarly on the subversive aspects of filmic disjunctions in Isaac Julien's *Territories*, which mounts a 'cultural struggle to decolonise and deterritorialise cinema as a site of political intervention'. By provoking a carnivalising of cinema as much as a cinema of carnival, Julien unleashes a 'dialogical tendency' appropriate to a 'diasporic people' – the black British of Afro-Caribbean descent.[2] Artists such as Julien and Black Audio Film Collective developed the techniques of montage, which, emphasising the multi-accentuality of the image, were posed against what Franz Fanon called the 'ideological fixity of the signs of colonial authority', in this case against the British postcolonial society of control.[3]

If the practices of Julien and Black Audio – and one could add Hatoum, Zarina Bhimji and others here as well – propose a 'critical dialogism', then it is, according to Mercer, one that challenges 'the monologic exclusivity on which dominant versions of national identity and collective belonging are based'.[4] They do so by eliciting the 'disjunctive time' and 'internal liminality', as Homi Bhabha has noted of the marginal and the migrant.[5] At stake in this internationalised network of discourses and artworks, which to some extent define the 1980s and early 1990s, is not only the defiant retort that diasporic practices made to postmodernist amnesia and spatial perplexity. It also concerns the critical vantage point they established on earlier and contemporary, competing modes of identity forwarded in the artworld at the time – particularly those that attempted to assert a branding of identity (whether in terms of race, gender, sexuality or nationality, as with the YBA phenomenon of the late 1980s and 1990s) as a ground on which to build their art practices.[6]

Still, despite these highly nuanced artistic treatments of the effects of displacement on subjectivity, by the mid 1990s came the gradual institutionalisation of multiculturalism in Europe and North America. The emergence of the pervasive administration of identity-based and minority-directed policies within governmental, civil and educational institutions contributed to a veritable 'race industry' of managerial practices.[7] In the post-communist, postnational era the result of such social engineering was the fixing of cultural, racial and sexual signs within the discourse of political correctness, which correlated in the 1990s to both the social divisiveness of identity politics and the commodification of ethnic and racial difference within neo-liberal globalisation. For theorists like Slavoj Žižek, as well as Michael Hardt and Tony Negri, 'multiculturalism' was then instrumentalised as 'the cultural logic of multinational capitalism';[8] for others, such as Paul Gilroy, the imperative for critical intellectuals consequently became one of writing 'against race', or at least struggling to

51 Isaac Julien (born 1960) *Territories* 1984. Colour 16mm, sound, 25 min
 Courtesy Isaac Julien and Victoria Miro Gallery, London
52 Francis Alÿs (born 1959) *Paradox of Praxis 1 (Sometimes Doing Something Leads to Nothing)* Mexico City 1997, video, 5 min
 Courtesy the Artist

retain the critical promise of multiculturalism outside its conservative institutionalisation.[9] However, to bypass the categories of race and class, as if they no longer mattered, would be wishful thinking (consider how they played out in the 2011 rioting in England, set within a context of the Coalition government's austerity measures, which some interpreted as class warfare[10]). Indeed, to navigate between these poles – between a questionable 'post-racial' politics and the continued existence of racialised and classed political and economic hierarchies – presents one major challenge for current practices.

That said, it was against the institutionalisation of multiculturalism – and its often simplified notions of difference and cultural identity – that artists during the 1990s challenged static categories of subjectivity, whether those tied to geographical place or those that continued the commitment to sexual and racial classes as a basis for a cultural politics of recognition.[11] Such imperatives contributed to the cultural development in the 1990s of nomadism, which presents us with a second formation in this genealogy of contemporary art and mobility. Consider Rirkrit Tiravanija's installation of nomad kitchens in which the New York-, Berlin- and Thailand-based artist would cook free Thai food for guests, as in *Untitled (free)* at New York's 303 Gallery in 1992; Gabriel Orozco's *Yielding Stone* 1992, a ball representing the Mexican artist's weight in plasticine, which he rolled around New York City; and Francis Alÿs's *Paradox of Praxis 1* 1997, for which the Belgian artist moved a block of ice around the streets of his adopted Mexico City for nine hours until it disappeared (fig.52). These projects exemplify the poetic lyricism and romantic sensibility of the nomadic. Freed from the constrains of fixed identity and detached from the postcolonial burdens of the struggle for minority rights that sometimes reinforced static conceptions of race, ethnicity and nationality, 'artistic nomadism' represented a new model of 'cosmopolitanism', as critics such as Jean-Pierre Criqui argued. While the nomad is 'always carrying along … a part of one's native country', he or she remains 'independent of the melancholy one ordinarily associates with uprooting', noted Criqui: the nomad is 'a mobile and polymorphous entity'.[12]

Unlike exile's involuntary relation to displacement – whose 'essential sadness', for Said, 'can never be surmounted'[13] – nomadism embraces dislocation as a permanent home with lightness and joy. Indeed, positioned by Hardt and Negri as a 'resistance to bondage', the nomadic represents a 'struggle against the slavery of belonging to a nation, an identity, and a people,' and a 'desertion from sovereignty and the limits it places on subjectivity', a desertion they see as 'entirely positive'.[14] In this regard, nomadism advanced a critical strategy for resisting the double tendencies of 1990s globalisation: on the one hand, its creative mobility challenged the homogenising aspect of capitalism that renders all places and things alike;[15] on the other, nomadism defied

the potentially regressive returns to localism, tribalisation and essentialist identities that the backlash against cultural and economic globalisation some-times inspired. As Achille Bonito Oliva put it, 'nomadic artists exercise their right to diaspora, their freedom to wander across the boundaries of various cultures, nations and media forms ... They adopt a tactic marked by cultural nomadism to escape the perverse consequence of tribal identity and, at the same time, claim the creation of what is symbol[ic] against the commoditisation of global economy.'[16]

Yet how critical is this artistic strategy? What means of social commonal-ity or political solidarity is available to this class of itinerant individuals? How does the nomadic avoid collapsing into the same debilitating loss of collective solidarity, the splintering of which plagued identity politics? For instance, even postcolonial critic Gayatri Spivak has proposed – contra nomadism's anti-identitarian posture – the 'strategic' use of an opportunistic and temporary 'essentialism' to unite people in order to achieve specific political goals.[17] If nomadism's individualising impulse impoverishes social alliances, then theorists have also criticised nomadism's lyrical and romantic tendency, where the poetic flight of fancy – which tends to dramatise first and foremost the artist's own privileged peripatetic existence – fails to reflexively consider the institutional, historical and geographical parameters of the nomadic, and ends up typically 'veiling the specific material circumstances of the gallery'.[18] These tensions become particularly apparent when mid-career retrospectives are organised for artists like Tiravanija, exhibitions that deploy a monographic format that reaffirms authorial identity despite the artist's attempts to vari-ously defy that logic via collaborative procedures, the elimination of art objects and non-autobiographical projects.[19]

What of the fate of the nomadic today, in a context where globalisation more than ever threatens to erase difference and particularity, and where the market's voracious appetite for mobility, flux and expansion makes the nomad an exem-plary role model for the trans-national capitalist? And given the resurgence of the nation-state in our post-9/11 environment, with the current governmental obsession with global terrorism and national security, what is the status of the nomadic in this new political environment animated by the fear of migrants?[20]

In view of this geopolitical framework, a further risk of the nomadic is to naively romanticise the privileges of borderless travel while overlooking how many disadvantaged people are excluded from that same freedom. In 1993, for example, Christian Philipp Müller performed Green Border, a project included in that year's Venice Biennale's Austrian pavilion, for which the Swiss artist was photographed crossing Austria's eight national borders, including those shared with the former Eastern-block countries of the Czech Republic, Slovakia,

Hungary and Slovenia, as well as the Western states of Italy, Switzerland, Liechtenstein and Germany. Along with his installation at the Austrian pavilion, which interrogated the architecture's historical relation to spatial partitioning and territorial divisions, Müller's was a complex symbolic act: it not only retrieved the historical connections between Austria and Nazi Germany (in 1938 the country had been annexed and its newly built Venice pavilion was formally associated with Germany), but also contested the remaining forms of geographical exclusion in the post-wall era by transgressing Austria's borders in the fictional persona of that nation's representative artist.[21]

Yet against Müller's implication that Europe was becoming a free, borderless zone the reality in the EU – as we now know all too well – was shifting towards the political imperative of stemming the tide of migration from the south and the east. The Schengen Agreement, instituted in 1990, is key to this history, for it created an open region within Europe but simultaneously acted to reinforce the EU's borders with its neighbouring areas. It did so, moreover, by exacerbating the impoverishment and oppressive political circumstances of nearby African countries by conditioning economic aid upon strict population control achieved through militarised border security.[22] As refugee camps and detainment centres for illegal immigrants have since proliferated across the European continent – as shown in various maps by migrant rights groups, such as Migreurop[23] – it seems increasingly problematic to celebrate the nomadic today. Doing so once expressed the radical hope of global citizenship, situated in the period of the waning of the nation-state and its sociopolitical hierarchies, particularly in the jubilant years following the dissolution of the Soviet Union, which was the historical context for Müller's project. And while this hope may survive in current struggles – for instance, one reads in the pages of *Empire*: 'circulation must become freedom … In other words, the mobile multitude must achieve a global citizenship'[24] – to sing the praises of nomadism today within the narrow scope of the European framework but *without* that radical political demand – as is done commonly in contemporary art discourse – appears self-congratulatory, even narcissistic. In such cases nomadism suggests a contemporary primitivism, one that subscribes to a fantasy of freedom from all attachments, but which cruelly operates in a system that denies that freedom to the very people from whom it borrows its name.[25]

The desire to avoid perpetuating the separation of citizen and refugee, and to contest the withdrawal of political rights from the migrant, has led to further modellings of exile within contemporary art. These build on the above-mentioned critical antecedents and yet are still in the process of emergence today. Consider one response to Europe's geopolitics of exclusion, which is to relinquish the false universality of the nomadic and turn instead to ethnographic

procedures and documentary tactics to expose the often far from romantic living conditions of actual migrants, exiles and refugees. Multiplicity's *Solid Sea 03* 2003, for instance, compares two parallel voyages of the same 70-kilometre distance through the Israeli-occupied West Bank, one travelled by a Palestinian from Hebron to Nablus via checkpoints and gravel roads, and another travelled by an Israeli from Kiryat Arba to Kdumin on special Israeli-built highways. Whereas the distance was roughly identical, the Palestinian's trip took five hours, compared to the Israeli's hour-long journey. The divergence between the two dramatises the significant disparities of mobility today, which depend on the identity of the traveller. Or take Ursula Biemann's video-essays, such as *Sahara Chronicle* 2006–7, which investigates northward transmigration in the Sahara, with the artist interviewing and documenting people desperately and daringly making their way from Niger to Libya or Algeria, with hopes of eventually gaining illegal access to Europe. These examples are salutary in that they reject the superficial romance of the nomadic in favour of exposing the circumstances of those excluded from its privileged realm. As well, they contest media stereotypes and governmental spin regarding migrants as so many criminals and terrorists, which tend to polarise camps, drawing citizens and refugees ever apart.

These models not only bear witness to the deeply ambivalent experiences of displacement, relaying both the hardships and pleasures, the pathetic indigence and the productive possibility; they also generate powerful aesthetic constructions that dislocate the viewers' space and time of perception and self-positioning. In doing so, mobility becomes a shared experience between artist and viewer alike, suggesting the basis of an emergent political construction. Think of Emily Jacir's performative, installation-based investigations into the everyday lives of those caught in the Israeli occupation and the corresponding Palestinian diaspora, such as her *Material for a Film* 2007; Yto Barrada's *A Life Full of Holes – The Strait Project* 1998–2004, comprising a photographic cycle depicting Moroccan migrants on the Strait of Gibraltar; Steve McQueen's cinematic treatment of migrant labourers in *Gravesend* 2007, which liberates them from the bondage of representation; and The Otolith Group's films that destabilise the temporality of nationality and empower the potentiality of historical oppositional struggles, including the politics of the Non-Aligned Movement and Indian feminist-socialism of the 1960s and 1970s, as in *The Otolith Triology* 2003–2009. In these cases the viewer is placed in proximity to what Said has called 'permanent exile', a term that draws on exile's metaphorical sense to describe a protean state of being, rather than a static existence without transformation over time, which characterises specific social, political and aesthetic circumstances. Said's notion comes close to what Giorgio Agamben calls 'being in exodus', that is, a perpetual experience of mobility that rejects normative divisions between the citizen and the refugee.[26]

Such positioning declines an ultimate homecoming, a national naturalisation or an essentialist opposition between the national and the migrant. Instead, the deconstructive force of this conceptualisation of migration – a term associated more with a voluntary self-positioning than the involuntary subjection of the refugee or exile – suggests, finally, a form of 'singularity' that concerns an infinite becoming, one posed against citizen and nation-state alike. As modelled in the art of Jacir, Barrada and McQueen, the aesthetics of mobility proposes an existential and experimental exile without the subjective exclusions along the lines of nationality, race or class.[27] As this articulation reaffirms the nomadic surpassing of identity, it insistently invents new criteria for the specificity of lived reality and collective association – whether it be territorial-based (for instance, using urban space as a site of connection and transit for ephemeral communities of displaced persons) or transnational political affiliations (as in global movements for social justice and environmental sustainability); or again they might be communities of sense (as in the building of social connections through artistic participation and discourse) or what curator Okwui Enwezor calls the 'diasporic public sphere' of international art exhibitions (where participants reflexively problematise their economic and social position, as well as transcend the limitations of location, to invent new terms for cross-cultural interaction).[28] Most importantly, these models represent forms of sociability that remain open to foreignness, mobility and flux – in distinction to the potentially generic nomadic set, and to the biological and ethnic ties of familial and regional bonds, to which some conservative and fundamentalist groups would have us return.

In these unstable times – and as the recent past teaches us – there is no single way to understand mobility in contemporary art, whether aesthetically or politically; inevitably, new formations will occur in coming years that will continue to draw on and reposition it in innovative ways, critical and creative alike. As the twenty-first century prepares for an intensification of movements of life – in anticipation of the coming effects of climate change[29] – migration is poised to become an increasingly common experience, and equally a source of conflict, like never before. Let us continue to look to art for ways to make the experience of mobility meaningful and socially just via its creative forms and political insights.

New Diasporic Voices

The 1980s marked a significant milestone in British art with the emergence of a new generation of artists of migrant backgrounds, mostly educated at art schools in Britain. This generation came to prominence against the background of the huge transformations and conflicts over Thatcherism in politics, widespread unemployment, the rise of far-right hate groups and growing fears and concerns over race and immigration. Compared to the earlier generation of migrant artists from the Commonwealth, who adopted the visual language of modernism with significant modifications, this mostly British-born and educated group of artists pioneered a variety of socially and politically engaged art practices that drew substantially on the influences of the art of their time: pop art, found images and objects, and appropriation.

It is important at the outset to recognise that this new post-migrant generation of artists in no way constituted a homogenous group. They were internally differentiated in terms of cultural identity, gender, approaches to art making, political affiliations and aesthetic strategies. Two of the most prominent artists to emerge during this period, alongside Eddie Chambers, were Keith Piper and Donald Rodney. Responding to inner-city riots in Bristol (1980) and Brixton (1981) they formed the BLK Art Group and The Pan Afrikan Connection, an association of black British art students (with Chambers, Marlene Smith and Claudette Johnson) and a series of radical exhibitions. Both Piper and Rodney drew on a wide range of influences that included the radical Pan-African politics and imagery of the US Black Arts Movement, the pop-cultural appropriations and 'cut-and-mix' aesthetic of artists such as Robert Rauschenberg, Andy Warhol and Jean-Michel Basquiat and the text-image juxtapositions of conceptual art. Piper developed a powerful body

of work that deconstructed and challenged surface representations of British history and memory in relation to the African diaspora. In the seminal *Go West Young Man* 1987 (see p.3 above), a fourteen-part series of photo-text montages on paper, Piper deftly combined autobiography (a father-son dialogue), images of black masculinity, slavery and family photographs to 'document' a searing and darkly ironic series of textual commentaries and visual journeys through the traumas of the Middle Passage.[1] By transposing historical memory and archive onto critiques of contemporary culture the work powerfully highlights the commodification of black bodies and the construction of black men as objects of sexualised attraction and repulsion in Western visual culture.

Rodney's evolution as an artist responding to conflicts over migration, race and identity, went hand in hand with a deeply personal struggle to come to terms with a progressively debilitating chronic illness, sickle cell anaemia, resulting in his tragic early death in March 1998 at the age of thirty-six. Far from surrendering passively to this deadly disease, Rodney fashioned a unique body of work that in its later phases drew materially and metaphorically on his illness. Using at various points burned hospital sheets, x-rays, blood, a wheelchair and pieces of his own skin, Rodney's works powerfully laid bare post-colonial questions of history, identity and belonging, far exceeding the limited labels of 'political' and 'angry' art that were used to describe the work of many young black artists during this period (fig.57).

The internal differentiation at the heart of the 'black art' movement is highlighted to some degree by the work produced by Sonia Boyce, Lubaina Himid, Sutapa Biswas and Chila Kumari Berman. Several of these artists had attended the First National Black Art Convention in Wolverhampton in 1982, but quickly formed

an all-female corpus through which to articulate the specific experiences of black women. In her early pastel drawings, such as *Missionary Position II* 1985 (Tate), Boyce places herself at the centre of the pictorial frame, inserting herself within a dramatic narrative about the role of religion and gender in the domestic space. The patterned wallpaper in the background, present in many of Boyce's pictures of this period, invokes the nationalist use of wallpaper by William Morris in a colonial context. It also alludes to the fashioning of the domestic space by many Caribbean migrants for whom the front room became a sanctuary against the hostile forces of racism and exclusion in broader society. In *From Tarzan to Rambo: English Born 'Native' Considers her Relationship to the Constructed/Self Image and her Roots in Reconstruction* 1987 Boyce continued her probing of modernist conventions by collapsing historical and contemporary narratives about colonialism, race and representation into the flatness of the same pictorial frame (fig.56). Using photocopy, collage and found images drawn from comics and magazines, this work brings into stark relief the artist's own self image as a black person born and raised in the UK. The work viscerally renders visible the stereotypical manufactured images emanating from the cinema and television – the media environment that many black Britons have to negotiate daily.

If the artists associated with the black art movement effectively addressed questions of migration and displacement through the enforced lens of 'race', artists such as Mona Hatoum, a Beirut-born Palestinian exiled in the UK, made crucial works in this period that lyrically deconstructed themes of dispossession, displacement and a sense of being out of place. Hatoum often participated in exhibitions and events of this period with an understanding of blackness in art as a non-racial, political stance in terms of a shared history of colonial exploitation and oppression.[2] As a member of the Palestinian diaspora exiled in the UK, Hatoum was stirred to

integrate a politicised conception of diaspora into her work in the wake of the organised massacre of Palestinian refugees in the camps of Shatila and Sabra in September 1982. Her works in the 1980s embraced performance, live art, video and installation with a focus on the (often mute) body that is subject to and resists external forces of physical and psychic violence. In the video *Measures of Distance* 1988 letters from the artists's mother to her daughter, written in Arabic, are superimposed in a partially obscuring, veil-like fashion over images of her mother naked in a shower (fig.55). A further dislocation occurs when extracts from these letters are read in English by the artist, emphasising the linguistic displacement between mother and daughter. *Measures of Distance* is a visual and poetic meditation on personal and political displacement, the pain of distance and loss in conditions of exile between a mother and her daughter and the possibilities and limits of language in mediating these relationships.

Rasheed Araeen, himself one of the earlier generation of pioneering migrant artists, also emerged in the 1980s as a hugely influential champion and vocal critic of the younger generation. A seminal figure in the story of migration and art in Britain, Araeen has consistently highlighted the exclusion of 'Afro Asian' and black artists from the mainstream of British and modern art history. Whereas some of the younger black artists rejected modernist aesthetics (in rhetoric but not necessarily in artistic approach) Araeen's artistic strategy strove to use the language of modernism to critique its cultural power from within. A prime example is *Bismullah* 1988, one of a series of 'Green paintings' Araeen made in the mid-1980s (fig.54). The piece is a 3 × 3 grid made up of nine panels, using a combination of painted, drawn and photographic surfaces, with elaborate gold-coloured Islamic patterning on the four green corner panels (green being a significant colour in Islam). The other five panels form a central cross with symbolic images of candles (central to

Christian imagery) and spilt blood, suggesting sacrifice and slaughter. The title of the piece, *Bismullah*, reformulates the Islamic Arabic invocation 'in the name of Allah' to mean 'in the name of the priest', in a move akin to the language games of conceptual art. The work exposes the 'myth of modernism's historical distance from traditional cultures'[3] by pairing seemingly traditional and religious symbolism with modernist and conceptual structures in the same space.

The quest for new artistic languages to articulate the complexities of the black and migrant experience in Britain through simultaneously incorporating and critiquing modernism was shared by a pioneering group of young filmmakers who rose to prominence in the mid 1980s, Black Audio Film Collective. The collective, who were also present at the inaugural National Black Art Convention in 1982, responded to the racial and economic challenges of the period by developing a radically disjunctive and poetic film-essay style that produced such key works as *Signs of Empire* 1983 and, in particular, *Handsworth Songs* 1986 (fig.53). This key work is a lyrical and poetic meditation on the traumatic aftermath of inner-city riots in London, Liverpool and Birmingham in the 1980s, combining a number of discursive and aesthetic elements: photographic montages; restaged dramatisations; archival footage, such as television interviews; and poetic voiceovers and sampled music tracks. These elements are not hierarchically assembled, so that no overarching narrative or voice emerges. Rather, meaning is constructed in the play and juxtaposition of narrative sequences, interstitial moments of editing, poetic interludes, and the cumulative impact of visceral images. The film is also a self-reflexive commentary on the role of the media in the disturbances, focusing on the way the press reported events and contrasting this with accounts of local residents and witnesses. Possibly more than any other work at the time the film exemplifies an archival impulse highlighting how many black artists began to forage beneath the surface of 'documentary' realities to reveal and open up counter-narratives and untold stories of migration, resistance and black struggle, unearthing the 'ghosts of other stories'.

One of the challenges of understanding the 1980s as a singular moment in the history of British art in relation to the question of migration is that it has become such an intense field of conflicting and shifting interpretations of the aims, direction and, ultimately, the successes and failures of this group of artists. Somewhere buried amid the often obfuscating fog of claim, counter-claim and polemic that has come to misrepresent this moment remains the vital fact that a powerful new visual language of diaspora and displacement was created, which radically transformed and widened the cultural and aesthetic parameters of British art. This art claimed a new diasporic space that explored the histories, conflicts and possibilities of being simultaneously 'black' and 'British'.

Paul Goodwin

53 Black Audio Film Collective, 1982–98 (John Akomfrah born 1958; Reece Auguis born 1958; Edward George born 1963;
Lina Gopaul born 1959; Avril Johnson born 1958; David Lawson born 1962; Trevor Mathison born 1960) *Handsworth Songs* 1986.
Film, 16 mm, transferred to DVD, colour and sound, 59 min

54 Rasheed Araeen (born 1935) *Bismullah* 1988. Photograph, acrylic paint and silkscreen on canvas 154.4 × 230
55 Mona Hatoum (born 1952) *Measures of Distance* 1988. Video installation 14 min 25 sec

56 Sonia Boyce (born 1962) *From Tarzan to Rambo: English Born 'Native' Considers her Relationship to the Constructed/Self Image and her Roots in Reconstruction* 1987. Photograph and mixed media 124 × 359

57 Donald Rodney (1961–1998) *In the House of My Father* 1996–7. Photograph on paper on aluminium 122 × 153

The Moving Image

You can hang a picture, but you cannot hang an image. The image seems to float without any visible means of support, a phantasmatic, virtual, or spectral appearance.[1]

If migration, in its broadest sense, is increasingly a contemporary condition at some time or another experienced by all – virtually or physically, temporarily or ongoing – the moving image is the medium that lends itself most adeptly to expressing this infinitely various condition. The moving image as a medium is not fixed. It is intangible, mutable, unsettled, until it finds a support. It captures motion and is itself endlessly transportable, inhabiting multiple forms at any scale or size, from projected installation to television, cinema, internet and mobile phone. Its temporal nature enables variable perspectives to unfold over time, to incrementally build a picture. As an artwork, it exists only temporarily, its parameters determined by and fusing with the environment in which it is projected.

Over the past decade, documentary imagery has come to occupy a pivotal place in contemporary art. The impact of mass media and information, combined with the development of prosumer digital technologies, has ensured moving images are increasingly mobile and accessible, putting the means of production and distribution into the hands of many. The tension created between the camera's role as a mechanical recording device that documents 'reality' and the ability to frame, direct and distort a subject has been harnessed by many artists. This dynamic between aesthetics and politics, the actual and the artificial, opens up a productive and critical space of doubt and uncertainty,[2] one which has the ability to 'bring distant events close enough to get under our skin and alienate what is close to us'.[3]

In *Hreash House* 2004, Rosalind Nashashibi presents an observational portrait of an extended Palestinian family in their house in Nazareth (fig.60). The camera records daily rituals in the run up to Ramadan: preparing food, cleaning, watching television. Long, static shots unfold in real time, allowing the viewer the sense of quietly inhabiting the household like a well-worn chair. Objects are given equal status to humans – the camera repeatedly lingers on the textures and patterns of fabrics and furnishings, while personal interactions captured appear incidental – and each shot is a constructed exercise in formal composition. The muffled, ambient noises of domestic activity are, from time to time, pierced by the sound of the call to prayer – an occasional reminder of the external world outside, and with it, perhaps, the broader political reality.

Hreash House continues Nashashibi's interest in enclosed communities, 'societies within society'; she describes the refuge she felt inside the house in contrast to the tensions outside on the street: 'I wanted to capture a sense of home being an entire community and a world by itself.'[4] Nashashibi's father is Palestinian and the film's particular quality of detached observation alongside a feeling of sharing in the intimate texture of domestic life is perhaps in some way attributable to her own complex relationship to the subject as both insider and outsider, temporary visitor and researcher into her own heritage.

Born in France to immigrant Algerian parents and UK resident for the past twenty-five years, Zineb Sedira has explored, through her recent film installations, ideas of migration, displacement and diaspora using the metaphor of the sea. *Floating Coffins* 2009 was shot in the harbour city of Nouadhibou in Maritania, the country's economic capital and home to the world's largest ship graveyard (fig.61). Littered with the rusting, decaying hulls of hundreds of boats, which have found their final resting place here from around

the world, this extraordinary but wasted landscape, where desert meets sea, is also the departure point for illegal West African immigrants hoping to reach the Canary Islands. Presented across an arrangement of fourteen screens umbilically linked by wires, *Floating Coffins* gives multiple perspectives on, and to some extent formally evokes, the debris-strewn landscape of its subject. Against the sedentary sculptural presence of these vessels, isolated pockets of activity are captured – flocks of migrating gulls and the barely detectable movements of tiny figures slowly circling the hulls, hunting for valuable materials. A sense of movement is also suggested through the sound of the relentless ebb and flow of the sea, yet is visually presented less as a means of transit and regeneration than a receptacle for human waste. This is a place in which industry, once used to distribute people and commodities across the globe, disintegrates back into the ecosystem; and through this transition from material goods to flotsam dispersed by the sea perhaps provides a metaphor for the increasing dominance of virtual economies and social networks over heavy industry and mass transportation. Sedira suggests that '*Floating Coffins* is a space where life, death, loss, escape, abandoned and shipwrecked journey's meet. It's both a toxic graveyard and a source of survival and hope.'[5]

The relationship between movement and stasis is also harnessed in Steve McQueen's film *Static* 2009, a seven-minute loop of the Statue of Liberty, shot from a helicopter circling around it (fig.58). McQueen reverses the perspective of the huddled masses at the statue's feet, bringing us up to the statue's eye level, combining closeups of its surface detail with shots that locate it in the cityscape. For many migrants entering the United States by boat the Statue of Liberty – which depicts a woman escaping the chains of tyranny that lie at her feet – would be the first image they see. Referred to as the 'mother of exiles', the statue has transcended its context to become a universal and transferable symbol of freedom and the new world. Confronted with her materiality at close proximity, however, one is able to detect the worn, weather-beaten patina of her surfaces, and she becomes, once again, an object. However, the camera's rotations confuse a sense of spatial perception, with both the statue and the cityscape beyond seeming to be perpetually on the move. In destabilising the statue in this way, and translating that sense of physical disorientation to the viewer, *Static* brings into question both its fixed identity and the values it represents. Furthermore, the pulsating throb of the helicopter blades evokes a sense of military menace, which, when paired with its opposite symbol, suggests that 'freedom and oppression are not opposed ... but inhabit the same space'.[6]

In *Railings* 2004 Francis Alÿs negotiates another fixed symbol – London's Georgian architecture – but here the movement is created by his passage on foot (fig.59). Alÿs left his native Belgium for Mexico in the mid-1980s and has participated regularly in international exhibitions since the mid-1990s, and so his status as a temporary resident or 'passerby' in foreign cities has become a condition of his working life, feeding directly back into his practice.[7] Walking – a means of negotiating a new city in a non-prescriptive fashion – and creating simple interventions into urban space have remained central to the work. In *Railings* Alÿs is filmed walking around Regency squares, trailing and tapping a drumstick against the metal railings, the subsequent sound dictated by the speed of walking and interruptions in the fencing, as well as the artist's own imposition of rhythm. As a foreigner in London Alÿs connects to the city physically though his actions, translating its form into sound and tracing demarcations of public space. This action links to childhood, or perhaps the ancient English custom of 'Beating the Bounds' – a means of physically acknowledging a parish boundary by tapping willow

sticks on the ground – and yet it remains unclear whether his actions are nonchalant, affectionate or provocative.

In each of these works, the artist acts as interlocutor between the viewer and the subject. They largely remain outside of the frame yet use devices to disturb cinematic space and underscore the constructed nature of what we see. The agitated movements of McQueen's camera, the meticulous framing of Nashashibi's shots, the fragmented sequencing of Sedira's imagery and Alÿs's physical interactions with London's architecture generate an uncertain sense that they are both in and out of their subject. These artists are negotiating a line between different worlds, opening up perspectives on spaces not usually visible, while transforming our perceptions through the filter of their own experience.

Lizzie Carey-Thomas

58 Steve McQueen (born 1969) *Static* 2009. Film, 35mm, transferred to HD, colour and sound, 7 min, continuous loop

59 Francis Alÿs (born 1959) *Railings* 2004. Video, 9 min 15 sec
60 Rosalind Nashashibi (born 1973) *Hreash House* 2004. Film, 16mm, transferred to DVD, colour and sound, 20 min

61 Zineb Sedira (born 1963) *Floating Coffins* 2009. Video, colour and sound, 8 min

Artist Interviews

John Akomfrah, Kodwo Eshun, Wolfgang Tillmans, Sonia Boyce, David Medalla

John Akomfrah

The sense of rupture that both marks the film *Handsworth Songs* and that it charts is two-fold. At a certain point you come to recognise that maybe you are marked by a kind of difference. The collective body – black youth, black community, West Indians, Africans – then attempts to assert what the parameters, the boundaries, the shape of that rupture should be. In other words, what form of difference would characterise your existence? It's both the recognition of something, and the attempt to then forge a language, a dialogue with the place [England], through that rupture. The film is in a way emblematic of that shift. It's an attempt to summarise a set of feelings, affects or ways of seeing this place that had been bubbling for my generation since the 1970s, from the moment when you felt that somebody – whether society or individuals, be it the police or whoever – thought you ought to be targeted as the problem.

As a young black man growing up in the 1970s you felt marked out for a special kind of treatment. And sometimes that treatment was absolutely dire. There was a moment when we thought, like all refusenik manifestos, 'Fuck it. We'll take this on. You're right, we are different. We really don't belong.' What we were trying to do with *Handsworth Songs* was provide a kind of topography of that transformation: where we felt it had come from, where it was going, the moments that marked it. The effort was to provide a kind of indexical machine that would swoop up these moments, real and imaginary, and present them as the timeline for what had happened. The point was to see whether there was any way in which what had happened in 1985 could

be seen to be part of a legitimate, symbolic chain of events in which the riots were the logical outcome. This was a rhetorical position, but we felt it had some grounds, we felt it had legs.

We weren't consciously trying to find a new aesthetic language, but in retrospect I'm not sure that we could have been doing anything other than that. Given the kinds of narratives we were trying to disassociate ourselves from – and the elective affinities we felt with certain strands of the avant-garde in the twentieth century – it seems almost impossible not to be claimed by a voice of alterity. The British film avant-garde were very quick to say, 'You are really avant-garde', having initially disavowed us. The gesture is a paternalist one, a way of incorporating you as a kind of footnote, in an unfolding tele-ological history of the avant-garde, and we really were resistant to that. Which is why I would say provocatively, at every opportunity, 'We weren't trying to be avant-garde'. Because that wasn't the impulse! We weren't trying to be a footnote to some pre-established history, we were trying to pose questions, not simply to traditional methods of the essay-film or documentary filmmaking, but also about what constituted avant-garde film practice, with its obsession with abstractions, non-representational forms of address and so on – questions that were at the very heart of ideas of representation. It was not easy to do. Trying to name this thing in the beginning as avant-garde just didn't seem the way to go. It seemed necessary just to do the thing first and then work out what it was afterwards. We knew we had a language of deconstruction, which would function pretty much in the Derridean sense – that there would be something left that would bear traces of other things, necessarily, because there were things we were serious

about, influenced by, loved – but would also feel like an attempt at transcendence, however incomplete that process would be. The gesture is to overcome what for us seemed to be mythologies or false paths, blind alleys that represented the certain way in which the black subject had been treated up to that point.

It is important to stress how sceptical the film was, both of the avant-garde as well as of traditional methods of filmmaking, because this really goes to the heart of diasporic identities. The archival goes to the very heart of how those identities are constructed and how they circulate in any culture, because diasporic identities, in the absence of monuments that attest to their existence, have repositories of what they mean in the very thing that's supposed to deny their existence. So if you're black British and you go looking for your Nelson's Column, it's not there, but there's quite a few documentary films and they chart your sojourn. The archival has this deeply problematic place in what one could call the migrant imaginary. It is both a repository of affects and gestures and a mark of our exclusion. It is Janus-faced, and if you want to arrive at something that is infused by questions of memory you have to at least address what it is that it purports to say. In other words, official memory is not one that outsider subjectivities can avoid, because you don't exist outside of it. So we always knew this centrality from the beginning – partly because we'd worked for so long with archival images, even before *Handsworth Songs* – and we knew that whatever we did was going to go back to that world in some form or shape. If you wanted to suggest temporality you had to use the historic relic. And temporality was precisely what needed to be suggested, because the official discourse at the time was

attempting to say that there was no temporality. These are just aberrations, spatial anomalies with no resonance, no value, no rhythm that spoke to the outside at all. We said, 'That's precisely what there is. There's a whole lot of temporality and not much else, actually. Not much present or future but there's quite a bit of time. So can we just address this question?' It didn't seem possible to do that without turning to the archive.

Handsworth Songs was meant to be finished for the third cinema conference in Edinburgh, organised by Paul Willemen, Jim Pines and others in 1986. But it was just not ready. So the first screening took place at the Birmingham Film Festival that summer. And that really was something. I think people were just stunned. A few people cried – I was one of them because I was just so relieved that we'd got it there. But I didn't realise quite how revealing of a certain kind of mood it was. It never struck any of us that this was the mood we'd caught, this *saudade*, this melancholia. None of us realised it until we saw it with an audience.

One thing we learned from that period, and I've tried not to forget, is the importance of committing to a process. The outcome is kind of irrelevant. Of course, that gets difficult the more you're working within institutions that require you to justify the outcome before a work is commissioned. But in an ideal scenario one commits to a process that is interrogative, investigative, deconstructive. The journey is it. It might fail, and there were several films that didn't 'work'. But not only is it a more honest process, it becomes a more 'creative' process through self-questioning, self-doubt and critical enquiry. Collective practice necessarily forces this process of interrogation onto the work. Should

we use stuff that seems as if it's written by Derek Walcott, or quote from Derek Walcott? Why would you want to write something which has elective affinities with avant-garde or modernist poetry from the Caribbean but is clearly being written from a black British perspective by people who aren't poets? We're not claiming to be Edward Brathwaite or Derek Walcott, but we want to say that we understand why one would need to write poetry about those moments. It's about trying to understand subjectivity. It's about trying to understand how you can talk about people who you're being told are not individuals, just statistics. The desire was to suggest that these people had names, genealogies, histories and, crucially, ambitions, which were not the same as the Ministry of Labour's. If you can get people to believe that, or at least accept the premise, then they might understand how it is that that ambition could be thwarted, sublimated and destroyed. If you can understand that there are affective journeys as well as literal ones going on, then one could see the root of it. You could see how dreams become nightmares.

Our desire was to revisit a moment that everyone involved in a certain debate said was done. But what no one was prepared to accept was that when you joined all those moments up they suggested a certain kind of marked and dark temporality. The implications were apparent, but only once you'd put them together. When you've got footage of a guy in a suit getting off a boat, followed immediately by an image of a kid running down the street and being held by police, you don't really need to say anything else. The fact that they coexist would begin to suggest that there might be some connection. What could be going on in this transition from one image to the other?

I came across an extraordinary bit of archive footage, Philip Donnellan's *The Colony* from 1964, which marked the form *Handsworth Songs* took. *The Colony* was populated by an extraordinary range of black characters. A bus conductor in the museum makes a speech, 'England is so rich with culture, there's nothing the living can do which would compromise it. We can elevate ourselves by learning from the dead.' I thought, 'There's no way somebody like me could ever make a speech like that.' So I realised that I had stumbled across something incredibly important, because in a way, it revealed a whole psychic universe, which had to disappear in order for us to become what we became. People who had to turn their back on a certain kind of identity and say, 'We can't be in this space of ambiguity anymore. We've got to go somewhere to be black.' Another guy from the film looks like an old-time Kingston crook who'd got on a boat and come here. He had a gash across his face, which he'd tried to cover with a beard but it hasn't quite worked, and he says, 'Well, I love you but the majority of you don't love we'. I don't think any of our generation ever addressed our connection with this place in terms of a lover's discourse. 'We love you, but you don't love us.' I thought, 'This is powerful, this is really, really powerful.' It was at that moment that I thought we have what Carlo Ginzburg calls an obligation to the dead. At this very moment, we have walked into the tomb of Tutankhamen, and it just happens to be black folk from Birmingham in 1964. How do you do justice to things that are now not part of language or gesture any more? And that's where the melancholia comes in, because you are literally watching the process by which the living dies in order for something else to live.

You're watching psychically that transformation from people being coloured, immigrant, Jamaican, Grenadan, Nigerian – into this thing. You're watching them struggle with that thing: 'Do we stay here, which is a space of solitude, but is marked and characterised by a certain kind of frigidity?' You might need to just walk across the room to the other guy and say, 'Hi, I'm from Accra, I know you're from Kumasi and we hate each other, but lets join up and do something'. You could just see a certain kind of subjectivity in flux, almost as it transformed itself into something else in order to survive. To turn that into the subject of *Handsworth Songs* seemed obvious at that point. Forget the historic trajectory. Forget the political trajectory. Let's just connect moments to moments, affects to affects. Let's just suggest that there might be a narrative.

I think the commitment to temporal recoveries is one of the ways in which you mark the spatial anomalies. If you can somehow understand the times, the place begins to emerge. It's the anxiety that characterises most migrant and post-migrant discourses. Where am I, where have I come from and where am I going? This emphasis on questions of transition and passage then seems to be a way by which one fixes an understanding of place. The location is arrived at, invariably, by those existential questions that are necessarily temporal ones. What was I yesterday? Yesterday I was the guy they beat up. What am I going to be today? I'll be the activist that fights against it. Where is this happening? In Brixton.

Questions of temporality were important, appropriately enough for a time-based artist and activist. You were aware of how your presence was a kind of sonic dissonance. Every time people talk about the

transformations 'black culture' has made in this country, whether it's a reflection of how Londoners speak or its effect on dance and music culture, they usually turn to the sonic. Over the last decade, I've become obsessed with other questions, spatial questions that were previously displaced by the emphasis on temporality. But the massive investment in the question of temporality is still there, which is why the archive continues to fascinate me. Wilson Harris is right, it's a kind of infinite rehearsal, because you never ask the same questions, or when you do, what comes back at you is never the same. There are similarities and overlaps, but in every single one of them, something else is tilled over, which has spatial and temporal implications.

One is aware that there are certain emotional recognitions one couldn't make about the sojourn in this space without taking on the very question of space. That seemed to me to be one of the things we were very seriously confronted with in the recent film *Mnemosyne, Nine Muses* (2010), which is concerned with the process of becoming. You are made by place. How do we suggest this process of making? Great historians and theorists always hint at this. You can't read E.P. Thompson's *The Making of the English Working Class* without understanding that you're talking about the emergence of subjectivities that are absolutely formed by transformations of space: the dislocation and relocation of people from one space – rural areas – into another space – the urban. And that it's not just, 'They went into the factory and became workers'; no, 'they went into factories and they became different kinds of human beings'.

Every migrant carries the two senses of place in their mind. You're arriving in a place that is relatively impervious to change, which is what

made it attractive in the first place; but the solidity will then allow you to make your home and raise a family, and those things make changes to that space. People don't make the journeys to come and die, they make them to come and live. And to live you transform that place. The very process of arriving at an assumption that one is going to make the journey already begins a temporal and spatial transformation, not just of yourself and where you are, but of that place. I don't think anyone who makes the journey is unaware of this duality.

Almost every single member of Black Audio Film Collective was at the inaugural conference on the black art movement at Wolverhampton Polytechnic in 1982, and I met everybody I got to know as the 'black art movement' there – Eddie Chambers, Keith Piper, Sonia Boyce, Claudette Johnson, Lubaina Himid. There were many differences between our approaches, but the sense that we were fellow travellers and in the same game was very clear. Questions around the 'black aesthetic' were the subject of debate. Does one arrive at it by trying to effect a distance between yourself and the traditions that have somehow formed you? Do you see yourself as problematically part of both what one could call a black art tradition as well as an avant-garde tradition? Do you see yourself as trying to open a third space? People were asking different questions of themselves, and where they stood in relation to the 'tradition' via this narrative of a black aesthetic. All 'movements' are characterised by a desire for affinity, through which people then try to mark out a trajectory of difference for themselves. We came together to have a meeting on what would be a black art movement, what constituted a black aesthetic. Just the recognition that there was a need for that seems to me to be

important, but the fact that people would even bother to discuss work around this question for so long has to be a marker of success. Was it going to be a wholesale import of something that happened in America in the 1970s, or even earlier in the Harlem Renaissance of the 1920s and 1930s? Could it be something that came from the Caribbean, could it be African or is there something here that one could use? Could it be the fine-art training or could it be the vernacular cultures? These are major questions and people were trying to figure out what it meant for them as practitioners.

The fact that a bunch of young black kids in the 1970s and 1980s even felt that this was something worth striving for was a great thing, whatever the outcome. And I think it's still relevant. As long as I'm alive it's still relevant! The obsession with black subjectivity, the interest in narratives by which one secures it, whether they're pictorial or time-based, the sense of the intimacies that have characterised the lives of people of colour in this part of the Western hemisphere needs to be understood. These are ongoing questions. As long as the diasporic sublime continues to be something worth stalking, chasing, then there is the relevance of a black aesthetics.

Edited text of an interview with Lizzie Carey-Thomas and Paul Goodwin

Kodwo Eshun

In his essay 'Components of the National Culture', published in *New Left Review* in July–August 1968, Perry Anderson analysed the implications of what he called the 'White Emigration' of Austrian, German, Polish and Hungarian intellectuals, who fled Nazi-occupied Europe for England during the Second World War. Anderson's thesis was that these Mittel-European immigrants, primarily based in London, understood themselves, and were received by the cultural elite of the era, as self-consciously conservative or 'white' migrants, in contrast to 'red' Frankfurt School Marxists such as Herbert Marcuse and Theodor Adorno who opted to live and work on the West Coast of the United States. What attracted figures such as Ernst Gombrich and Edgar Wind to settle in Britain was, precisely, the placid settlement of its anti-fascist imperialist culture.

Intellectuals such as Gombrich and Wind, who are unfailingly referred to as emigrés rather than immigrants or migrants, found sanctuary from the turmoil of European revolution in the reactionary climate of British academia and were able to achieve commanding positions of influence within its provincial precincts. On one hand, the trauma of their enforced exile was assuaged by the vision of Britain as a safe haven built upon uninterrupted traditions of instinct and custom. On the other hand, to quote Anderson again, the 'insular reflex and prejudice' of Britain's artistic establishment was 'powerfully flattered and enlarged in the convex mirror' that the white emigrants 'presented' to it; the 'extraordinary dominance' of these expatriates can be attributed to the

ways in which they managed, simultaneously, to reinforce the 'existing orthodoxy' and to exploit the 'weakness' of an establishment defined according to antiquated beaux-art principles.

From the perspective of white emigrants, Britain appeared to be a post-ideological state, an Empire whose bourgeoisie failed to pursue a violent revolution. It is within this context that the critical role played by historians such as Wind and Friedrich Saxl, in their association with the Courtauld and Warburg Institutes, becomes apparent. These thinkers helped to radicalise the disciplines of art history and art theory and simultaneously to fix them in stasis. To return to this moment is to think through the somewhat overlooked implications of white European mid-century migration; by integrating this era into the familiar narrative of artistic transnationalism and situating both within the wider context of the formation of British national culture and its specific traits of anti-fascist imperialism, the question of migration emerges as a central condition for post-war history.

In an intriguing footnote, Anderson noted that a 'number of the greatest names in modern art' such as Mondrian, Gropius and Moholy-Nagy spent a 'brief and obscure sojourn here, before crossing the Atlantic to a more hospitable environment'. The reception these migrants received indicated the insularity and provincialism of British culture; it suggests that modernism in Britain was marginal, provisional, and above all encumbered. It flourished in occluded pockets here and there but was largely excluded in the name of Britishness understood in terms of the continuity of custom.

We can think through the continuities and discontinuities between practices of modernism, modes of migration and inhabitations of imperialism

if we make a jump cut to the early 1960s. The insular geography of intellectual Britain at this moment makes it difficult to imagine any of the white emigrants encountering artists such as Aubrey Williams, Frank Bowling or Rasheed Araeen. What if Adorno, labouring on his research on Husserl in Oxford, had met figures such as Edward Kamau Brathwaite or Stuart Hall or any of the other writers, poets and broadcasters of the Caribbean Artists Movement, many of whom were also based at Oxford? What might they have spoken of? In the context of the new Commonwealth, defined by Hugh Gaitskell in 1961 as the dispensation that aspired to reframe the British Empire as a family of independent nation states of Africa, Asia and the Caribbean, painters such as Bowling and Williams were cosmopolitans who saw themselves as heirs to the histories of Western art, classics and literature. As beneficiaries of these traditions, they elected to situate themselves within the imperial metropolis of London in order to inhabit its institutions, its art schools, universities, museums and galleries. We could say that these intellectuals exhibited, in their distinct ways, a generational imperative to reinvent the cultural legacy within which they had been educated. The aspiration to contribute to and transform those traditions was not enforced; indeed, it was elective, yearned for, desired. Their migration might therefore be perceived as a homecoming in an aesthetic sense. Despite the distance between Trinidad and the UK, there was a sense in which these figures felt themselves to be already at home in England. Modernist painters such as Williams and Bowling were not refugees or exiles looking to reconstruct a ruptured homeland; it is possible to see the ways in which they helped to constitute a 'virtual cosmopolitanism', to use Partha Mitter's term,

within Britain, one that emerged from within a complex condition of thwarted homecoming and encumbered belonging that was specific to the early 1960s.

As J.G. Ballard was reorienting science fiction away from the far future towards the perspective of the present in his condensed novel *The Atrocity Exhibition* (1970), Bowling was working upon on his map paintings. He had relocated to America out of frustration with the impasses he faced within London's art avant-garde. Paintings such as *Who's Afraid of Barney Newman* 1968, the two versions of *Mother's House on South America* 1968 and *Bartica Born I–III* 1968–1970 indicate a revisionary Atlanticist imagination that had repositioned itself outside Britain in order to formulate a mode of what Kobena Mercer calls discrepant abstraction. In these paintings the continental presences of South America and Africa become outlines of land masses, their intra-territorial borders elided. Nation states are submerged within chromatic fields, vertical blocks, atmospheric deluges and meteorological downpours. Glimpsed through penumbras and halos, the geographies of America and Africa become cartographies of indistinction, inviting indefinite affiliations that surpass transnationality and terracentricity as the basis for identification.

To speculatively reconstruct this moment is to see the ways in which narratives of transnationality tend to emplot a broad perspective, as Google Earth might survey a land mass. There is a tendency, as this conversation indeed exemplifies, to offer generalised, generational propositions in an effort to do justice to the world historical character of migration, its asymmetrical implications, its variegated practices of affinity, its multiple paradoxes of belonging. What would be productive, especially for practices

of post-war painting, would be to change the scale of interpretation, to produce close, even microscopic readings that slow down in order to move across a painting's surface, so as to take the hairline fracture of varnish as seriously as its gestures, marks, stances, attitudes, sensibilities, positions, postures and signatures.

A close reading of moments from Black Audio Film Collective's essay film *Handsworth Songs* 1986 offers itself as an experiment in close reading. The film takes as its point of departure the riots that broke out in the streets of Handsworth, Birmingham, in September 1985. It returns to the newsreel archives of the post-war era that document the moment in which Jamaican 'arrivants', to use Edward Kamau Brathwaite's term, disembark from the *Empire Windrush* at Tilbury Docks, Essex, in June 1948. What *Handsworth Songs* makes visible, and audible, is the diction specific to the pre-independence era; the calypso singer Lord Kitchener sings the words of 'London Is the Place for Me' with a precision that is at pains to demonstrate its gentility. You can hear this same desire to prove one's Englishness in the words of an anonymous interviewee, whose heavy coat and scarf indicates the extremity of winter. As he stands in a suburban street, talking into the microphone of an officious reporter, one hears, above all, the need to reassure white television viewers: 'we', meaning the respectable, working-class Caribbeans, he insists 'do not want any special favours', our only wish is to be 'treated like everybody else'.

The film cuts to colour; a red car, turned on its side, is consumed by flames and billows black smoke. Successive interviews with Handsworth inhabitants follow: the eloquent English of Sikh activists is counterpointed by strong Jamaican accents, made more inaccessible

still by a use of Rastafarian slang that makes no concessions to non-Jamaican audiences. The jump from the painstaking diction of the post-1948 generation to the slang of the mid-1980s, from voices that signal their desire to belong to voices that have no desire to placate, makes audible a change in mood from the aspirational migration of the former to what Dick Hebdige calls the 'internal migration' of the latter. In the hostile gaze and deliberately impenetrable idiolect of the first generation of British-born Caribbean youth educated in Birmingham whose accents are forged from immersion in roots reggae sound-system culture, one hears the unmistakeable accent of a psychic migration. A generation has turned its back on a Britain that had rejected its parents, has left an England that it has renamed Babylon in order to inhabit a community fashioned from pirate radio and soundclashes, 12-inch vinyl dubplates and camouflage jackets, dreadlocks, sufferation, downpression and tribulation. This move – from a community that wanted nothing more than to belong to a subcultural elite that wants to do anything but belong – is what *Handsworth Songs* continually reveals. The conjunctions and disjunctions between an unrequited love for Englishness and what John Akomfrah calls a 'secret history of dissatisfaction' with Englishness emerges, periodically, in 1978, 1980, 1981, 1982, 1985, 1989, 2005 and 2011 in disturbances to the violent civility of the nation.

Handsworth Songs argues that the causes of these disturbances are to be located in moments that exist in times and places far removed from the immediate scene of the riots of 1985, and, which, as a consequence, bear little or no resemblance to the topicality of those riots. What if an understanding of the events of September

1985 entailed turning back to newsreel footage of a workers' Labour Day Parade through the streets of Birmingham in 1937? To a sequence of a girl, dressed as Britannia, seated on a throne, pulled along on a float? The relation between 1937 and 1985 is not causal or even dialectic; it is allusive, associative. *Handsworth Songs* insists upon the importance of constructing non-linear relations within the context of political crisis dominated by the demand for causal explanations that could provide narratives capable of exorcising the national malaise. Journalism, in all its modes, from radio to television to newspapers to blogs to Blackberry to Facebook to Twitter, attempts to be present to the urgency of the present, as it unfolds; it locates the causes of crisis within the present of the crisis and then repeats its narratives of cause and effect in the form of loops. Black Audio Film Collective insisted on the right to take all the time necessary in order to make an artistic intervention; the time that was needed to construct acausal montages that operated outside of the instant response times of journalism.

The archival impulse that can be observed in Black Audio Film Collective's monumental slide-tape essay *Expeditions: Signs of Empire and Images of Nationality* 1982–4 and in their essay films such as *Testament* 1988 and *Twilight City* 1989 can also be seen as a methodology for securing legitimacy in the present, as a way of responding to what is missing in the present and of accepting that the history of the present exceeds its topicality. *Handsworth Songs* formulated a critique of reportage that was clearly articulated in its famous principle of representation: 'There are no stories in the riots only the ghosts of others' stories'. This principle can be stated as a hauntological formulation; it turns towards the archival in order to make visible and audible that which is not

present within the present but which persists into the present as a condition of what Paul Gilroy calls post-colonial melancholia.

Handsworth Songs reworked archival sequences from cinema newsreels produced prior to, and immediately after the Second World War, as well as from television documentaries broadcast during the 1960s. The authority of these sequences stems from their mode of address, which constructed an imagined community of Britishness before which the migrant was continually called upon to demonstrate her or his desire for belonging. The subtlety of *Handsworth Songs* not only stems from the ways in which it decouples images of the Caribbean arrivants from the authorising commentary in order to produce new narratives; it also stems from the ways in which the film retains those original authorising commentaries in order to allow those voices of power to speak, to justify and to legitimise themselves. In doing so, those voices condemn themselves through their own speech; what is more, they gain a peculiar poignancy from their insistent inability to hear and to respond to the love that respectable, working-class Caribbeans and the intellectuals of the Caribbean Artists Movement maintained towards Englishness, a love that was, in its own quite distinct way, just as conservative as that of the white emigrants.

One reason for curating *The Ghosts of Songs*, the exhibition and publication dedicated to the work of Black Audio Film Collective at FACT, Liverpool and Arnolfini, Bristol, in 2007, was to make public some of the ways in which the practice of The Otolith Group was informed by, and remains informed by viewing and reviewing the ways in which Black Audio Film Collective rethought the inherited form of the essay film. What the form of the essay film and the video-essay

makes possible are works that allow for the suspension of the hierarchy between creation, criticism and curation. For The Otolith Group, the essay film cannot be reduced to questions of genre, to the use of so-called found footage, a poetic voiceover or the use of Standard 8 footage from a family archive. What is important is that the essayistic work exists in a zone of indistinction in which the distribution of roles between the artist that creates, the critic that criticises and the curator that organises becomes unstable, intermittent, indifferent, unaccountable, even irrelevant. The energy generated by this practice of indistinction can be understood as a kind of reflexivity that borrows from film theory and art theory while operating in a register that is speculative, autodidactic and self-authorising. What then emerges is a question: what is the relation of essayistic practices and modes of reflexivity to the broader condition of twentieth-century migration? What do these formal questions make thinkable?

One way to answer this is to turn again towards the writings of J.G. Ballard, whose novels and non-fiction have proved crucial for The Otolith Group. Ballard once pointed out that science fiction tended to be produced by authors that, either through illness or through living in another country for a short period at a critically young age, perceived themselves to be internal exiles from the country within which they were socialised and formed. This period of involuntary exile is crucial to the science-fictional gaze, to a perspective of viewing the present as if from a distance. Science fiction offers perspectives into what Ballard called the earth as the alien planet; for The Otolith Group, there is a profound relation between the tropes of science fiction and notions of migration.

If the presence of the migrant is traditionally understood to bear witness to distant forms of political violence, then, it is possible to ask, what forms of temporal disturbance are being made present through this appearance? In so far as science fiction aspires to produce modes of estrangement from the present, a submerged yet persistent relation can be discerned. From the perspective of an exile in the future, the hostile present takes on the appearance of a series of ruins, of an ideological junkyard. In February 2003, in the aftermath of the global demonstrations against the impending invasion of Iraq by the Coalition of the Willing, the notion of an exile in the future offered a form of speculative exodus through which The Otolith Group could paradoxically inhabit the collective mood of depression, anger, impotence and anxiety that millions of people experienced. *Otolith I 2003* suggests that experiments carried out with and on the body – in this case, through inhabiting the condition of microgravity – might be necessary in order to keep faith with the mood of political despair in the face of demand to accept the war and to move on.

Experimenting with the body in order to catalyse a dimension of psychic migration: this is one way of understanding Susan Hiller's *Dream Mapping* project of 1974. In a designated site within the Hampshire countryside, Hiller invited ten participants to embark upon a speculative cartography of dreamtime. Each night the participants would set out on an exhausting journey across the endless terrain of the mind. Each day, they returned to log their findings in dedicated notebooks using a notation system developed to transcribe their discoveries. The individual diagrams and notations from these notebooks were then assembled to form a collectively produced dream map. Might these notebooks of a return from a hidden continent, these notations from atemporal time, these collective maps from an unmappable dimension be seen as experiments in producing a group subjectivity that updated the Surrealist aspiration to produce a new political unconscious?

To make a jump cut from 1974 to 2011 is to situate artistic practice within the present of the communicative matrix that demands continuous stimulation, participation immersion and interpassivity. In his recent book *Retromania: Pop Culture's Addiction to its Own Past* (2011), critic Simon Reynolds characterises the first decade of the twenty-first century as an age of digital abundance that is distinct from the 1990s, that can now be positioned as the final, conclusive moment of analogue scarcity. The digital present is characterised by continuous, archival accumulation; cultural memory no longer dissipates or disappears; instead, it aggregates, exponentially. Youtube, to name only the most immediate example, should be understood as an unregulated, collectively produced continent of uploaded files, the sprawl of which invites and incites methods of associative archaeology. Under such conditions, according to Reynolds, contemporary cultural production can no longer be characterised by methodologies of appropriation; instead, it is preoccupied with excavating and recombining new narratives from the revenant images and remnant sounds from the furthest reaches of the internet. What are the artistic implications of this cultural horizon? Within these practices of associative archaeology, can we discern forms of migration that are specific to the communicative capitalism of the second decade of the twenty-first century?

Edited text of an interview with Lizzie Carey-Thomas and Paul Goodwin, further revised by Kodwo Eshun

Wolfgang Tillmans

One aspect I really like about being a migrant is that you can escape the things you don't like about your home country, its texture or fabric, or parts of the national character, whatever they may be. At the same time, you can detach yourself from the negative characteristics of your host country, as they don't really touch you as deeply. The bureaucracy of your home country affects you more because it perhaps reflects what's inside you, whereas something negative in a host country is not a horror within your own psyche. I don't think most migrants are aware of that psychology coming into play before they actually take the step. It's not a motivation – well, for me it wasn't – but it can turn out to have a powerful and very liberating effect.

I didn't leave Germany because I didn't like it, but because I really liked London, and British pop culture in particular. I came to London to study, but I already had a longstanding affinity with the city through my teenage years so I think it was always clear that after college I'd stay on. Apart from a brief spell in New York, I've chosen to make London my home for the last twenty-one years. London and Paris are the only cities of a truly cosmopolitan size in Europe. Germany is federal in nature, there isn't a centralist capital, and there is something quite centre-of-the-world-like that London represents.

Even though I felt very drawn to British culture, at the same time I think I was lucky that I stayed in touch with my German origins, and in particular with the Rhineland, where I'm from, where there was a long tradition of appreciation for modern and contemporary art. I actively chose not to be an artist clearly identified with historical German photographers. I had a fledgling awareness of the influence of Berndt and Hilla Becher on the generation of art students who studied under them in Düsseldorf, as well as the Rhineland tradition of August Sander, which I could have chosen to be part of, but didn't. At the same time I didn't go out of my way to become entirely British. I didn't reject my German-ness in the early 1990s. I was never affected by the narrow-mindedness that characterised art journalism or the celebrity culture of the art world at that time in Britain, perhaps because, as a voluntary migrant, I could pick-and-choose my affiliations and influences.

For a large part of the 1990s I thought hard about where the best place was for my work. Between my hometown Hamburg, Bournemouth, London, New York and, very briefly, Berlin, I was hoping I could find a pattern, an understanding of which place was the most conducive to working. But time and again I've come round to the realisation my work is not tied to a place. It is located within me.

I'm very interested in the different relations between people and nationalities and how different people arrive at similar things by different means. Since exhibiting internationally and working regularly with large teams in museums, I've found it amusing how similar, in the end, people are, despite going about things in different ways.

I possess a deep desire to reach the universal points that connect us, rather than those that divide us. Underpinning all of my work is an interest in relativity. I'm interested in the specificity and the difference of things, but also how they all coexist non-exclusively, like language: black and white or yes and no. And that's maybe where the rhetoric of nations, nationalities and borders come into play, since they aim to define something, when in reality I find definitions to be relative and fluid. And that's what I try to express through a lack of hierarchy, or crossed and mixed hierarchies, in the presentation of my work.

There is a lot of excitement about the internationality of London's art world and how this emerged over the last twenty years. It's a well-tracked phenomenon, but it's also in step with the internationalisation and globalisation of the world. A singular phenomenon in Britain is its relationship to the Commonwealth; who convened in London from where, and how this did or did not impact on the London art world. Many artists arrived in Britain in the 1950s and 1960s, but what they produced was not considered 'high art', which I instinctively feel is in danger of being under-exposed in light of the huge success of post mid-1990s London.

In many ways Britain deals very well with immigration, in the way that it incorporates and assimilates what it likes. When I was nominated for the Turner Prize in 2000 I was described as 'London-based, German-born'; whereas in Germany, for instance, even if you were born there you would always be, say, 'a Turkish artist'. Here I feel the fact that you are based in London or Britain is considered more important than where your parents are from.

Being an island, Britain might have a sense of splendid isolation, but there has always been a process of osmosis, of ideas and crafts permeating. The sea is a stronger border than land, although culturally I guess, from the Middle Ages until the modern era, a nation's borders were not so influential, as more importance was given to cities and regions. Britain has always had that firm border. Foreigners are amused by how the British talk about 'Europe' as separate from them, as 'the continent'. One could say that's a funny quirk, but it's also a grave misjudgement of reality. Of course, as a semi-Brit, I also tell people, 'well, it is different to have this water around us'. And it is.

Edited text of an interview with Lizzie Carey-Thomas

Sonia Boyce

The early part of my art training was relatively traditional. My life-drawing tutor, Arthur, would often complain that I drew the figure without any context. I was more interested in the figure itself. When I started to make a series of drawings about growing up in the UK, Arthur's voice would be in my head saying 'the figure's got to be in a context'. I was looking at the work of Frida Kahlo; she was a real ray of light for me to think about how one could, in a modernist sense, speak about the experience of now. To appease the voice of Arthur, and as a shortcut to filling in the background space, I began to look at wallpapers, because in terms of my domestic experience as a child, I lived in a very multi-patterned environment. I looked at William Morris wallpapers and some of his philosophies, and these two elements anchored how I articulated my experience of growing up in the UK. At that point I was in my early twenties, but really I was thinking more about my parents' generation – or, rather, viewing my generation through the experience of my parents' generation – seeing the home environment as a Caribbean experience, almost a hermetically sealed space in stark contrast to the experience of some of my friends.

The history of colonialism is embedded in my works. I mentioned Morris, who had made a wallpaper to commemorate Queen Victoria's golden jubilee as Empress of the British Empire. In the wallpaper he incorporates the four continents that Britain conquered, and this sits in the background of one of my early works, *Lay Back, Keep Quiet and Think of What Made Britain so Great* 1986, which is imbued with connotations of the migratory journey between the UK, the Americas and Africa, Asia the Caribbean and back again.

In my early years at art college I quickly became involved in feminist art debates. One debate raged over whether the female body should be represented at all, as it had been over-depicted in art history and contemporary culture; another debate challenged the primacy of painting. My early works were drawings, and feminist art theory was looking at forms of visual art practices often undertaken by women, such as drawing and the decorative arts, which were often ascribed a lower status. And so working with these under-valued forms was an open challenge to the dominance of traditional art.

I was also involved in debates about the very limited imagery of black people. This was at the time of an emerging black British art scene and there were lots of black women artists identified with feminism who were looking at, talking about and deconstructing imagery, seeking alternatives to stereotypes of the black female body. These discussions involved artists such as Lubaina Himid, Sutapa Biswas, Ingrid Pollard, Simone Alexander and Martina Attille, to name but a few. The domestic space – which was very much a matriarchal space – seemed to be the best resource for talking about my parents and the generation that had migrated to the UK. I used a lot of text, as titles or within the drawings, as a means to bring in a particular use of language – *Missionary Position* I or II, *Rice and Peas*, for example – to suggest religious and historical legacies within a domestic context. I was very much at odds with Christianity at this point, but had grown up in a Christian household, and in a much wider context, religion was a fundamental part of the black diaspora experience.

One of the key things that I felt when I was at college was that modernism, though it posed as a universal language, curtailed the idea of being a modernist simply by virtue of my being black and female. The exclusion of work by artists of African or Asian descent from the story of modernism is something that artist Rasheed Araeen talks about extensively. I was interested in the late modernist question of truth to materials. For me, there was an attempt to both flatten space within the picture plane, through the use of flat pastel colours and patterns, and at the same time flatten depictions of time by making connections between a colonial past and a migratory present. I was trying to imbue the works with a content that related to the form they took. There is a work by Frida Kahlo in which she is depicted as a child with images of her father and mother, a genealogy that she stands in the middle of. My drawing *She Ain't Holding Them Up, She's Holding On* 1986 relates to that painting, but it also, in another way, speaks to Magritte's *The Treachery of Images (This Is Not a Pipe)* 1929, and the way representation can not always be relied upon.

I'm often addressing the question of how representation operates. The late 1970s and 1980s was an era in which images of the body were being deconstructed. When I was at college John Berger's book *Ways of Seeing* was presented almost as the starting point of art history. Representation itself was under great strain, while at the same time we were being told that, as a black person, one stands as a representative figure for all black people. So of course, depictions of one's own image as well as other representational images formed part of the deconstruction process. It was a widespread debate that was cutting across questions of gender, race and

sexuality. There was a resurgence of the figure in art in the early 1980s, almost in opposition, one could say, to abstraction. To a certain extent, Greenbergian theory was withering away. There was a sense that this new influx of artists dealing with the figure, the body and representation were fighting against a particular doctrine. Now, of course, it's much more playful, less fraught, but at the time there were stand-up fights. Punches were thrown. It felt like a very turbulent time, with nothing certain and everything becoming an enquiry.

It seemed as if the position that painting occupied was no longer tenable. A lot of deconstructive work was taking place and there was an emphasis on perishable works, which could better articulate this new paradigm. Black Audio Film Collective's early tape-slide works, for example, borrowed from earlier modernist traditions of collage and dada. Nobody was openly talking about the aesthetics of this – content and the critique of representation was privileged over aesthetics – but I think that now it is possible to talk about the relations between these without either being necessarily compromised. Part of this focus on content may have been down to the urgency of what we were trying to articulate. And it was a struggle. It wasn't as if one could easily say, 'This is the language that's best suited to what we want to say', which is why we all came together even though we were working with diverse art forms. We were all looking for a language with which to articulate the experience of that time.

From the outset, black art students in the 1980s were at the forefront of self-organising exhibitions and important events. For instance, the BLK Art Group organised the National Convention of Black Artists as well as their own exhibitions. I was associated with this activism. The way to be in a show was to organise one's own, as well as to get one's mates to be in it. This is not new and there are many generations of artists, particularly post-war artists in Britain, who've done similar. During this period museums and galleries – mainly public and independent spaces – were inviting one or two black artists to curate a show at their space. I was asked to co-curate something at the Whitechapel Art Gallery, along with Gavin Jantjes and Veronica Ryan, which became *From Two Worlds*. Almost immediately after leaving college I was asked to be on visual arts advisory panels, such as the Arts Council Collection, but again as a 'black' representative figure. A significant part of my career, alongside making work, has been as part of these strategic dialogues with arts institutions.

By the end of the 1980s I got to a point where I didn't want to be the centre of the work any longer. I didn't want to be the representative figure. It felt like I'd worked myself into a cul-de-sac where I could only speak about myself. The feminist chant 'The personal is political' had been the starting point and from there I started to move outwards. I didn't want to be in the position of acting as some kind of informant for a whole group of people. That was part of the logic of identity politics, one can only speak about oneself, one can't speak beyond oneself, and I found that really very problematic. And so I started inviting other people to be in the work.

There has been a paradigm shift over the past thirty years that has been about bringing different approaches to art making and different communities together. I know 'multiculturalism' is now considered a dirty word, but Britain has continually coped with many communities, making sense of what Britishness is. I sit here and I'm looking at a Union Jack flying on the banks of the South Bank that has the colours of the Irish flag. Just twenty years ago that would have been an outrage, it would have been all over the media. This reminds me of an artwork by Eddie Chambers, and another similar work by Mark Wallinger – both played with the colours of the Union Jack and caused controversy.

Art practices have been challenged in so many ways that art doesn't just talk to itself anymore. Cultural theory has had an enormous impact, so that we are now working with a greater sense of historical continuity and discontinuity, and there are no longer such hard and fast doctrines. Migrating communities have been part of this literal and metaphorical groundswell, both creating forces of contestation and providing processes of change in cultural and political space.

Edited text of an interview with Lizzie Carey-Thomas and Paul Goodwin

David Medalla

Migration is a constantly changing state I am in. I never thought of myself as an exile: I feel at home anywhere in the world. I was a boy of nine when I first left my native Philippines, as an 'accidental stowaway' aboard a luxury ocean liner from Manila bound for Hong Kong. I was a child prodigy in my native country and, when I was twelve years old, was chosen to go to Camp Rising Sun, a scholarship camp for boys, run by the Louis August Jonas Foundation, in Rhinebeck, New York. It was here that I made the acquaintance of the American folk singer Pete Seeger and, shortly after the camp ended, the American poet and teacher Mark Van Doren recommended me as a special student at Columbia University, New York. At Columbia, I studied ancient Greek drama under Professor Moses Hadas, who was appointed my personal tutor, modern Western drama under Professor Eric Bentley, modern European and American literature under Professor Lionel Trilling and Western philosophy under Professor John Randall. I also took the poetry writing class under Leonie Adams. I shared a 'railway-type' apartment at 616 West 116th Street off Broadway in Manhattan with James Tenney, a protégé of electronics composer Edgard Varese.

After classes at Columbia University, I would explore Times Square in the early evenings, where I met the actor James Dean, who became one of the first people to encourage my art. Another person who offered encouragement was fellow Filipino and poet José Garcia Villa. Together, with a number of young artists, dancers and musicians, we frequented the cafes of Greenwich Village. It was the 1950s – the height of the Beatnik era in America – and my parents were afraid that I might turn into a junkie. They sent me to England, where an English relative of ours became my guardian.

I lived with this English uncle in an elegant flat at Cumberland Terrace on Regent's Park, and on alternate weekends explored Hampstead and Chelsea. In Mr Norman's Bookshop I met Elias Canetti, the writer of *Auto-da-Fe*, with whom I drank cups of coffee in the cafes of Hampstead, while discussing the merits of Chinese civilisation. In the garden of the King William IV pub in Hampstead I met the writer Christopher Isherwood on a short visit to England from his home in California. I invited Isherwood for tea at my uncle's house. I wanted to talk to him about his Berlin days; instead he talked to me of Vedanta philosophy. In the evenings I explored Covent Garden and Soho. I painted watercolours in the docks and oil paintings in Little Venice. London was a nice place to live in the 1960s. As an artist you needed to like going to pubs and to join drinking clubs in Soho, such as the Colony Room on Dean Street, where painter Francis Bacon and poet John Heath-Stubbs hung out. The writer Colin MacInness, author of *Absolute Beginners*, took me to the Colony Room.

The first exhibition I attended in London was a solo show by Picasso at the Tate. During the opening party I met the American photographer Lee Miller, the Surrealist painter Roland Penrose and the art dealer Robert Fraser. Later I made the acquaintance of English artists Sir William Coldstream, William Townsend, Robert Medley, Winifred Nicholson, Rita Donagh and Keith Vaughan. I also hung out with Rasheed Araeen and artists from Africa, Asia, Australia, New Zealand, the Caribbean and the Americas. Araeen was a brilliant polemicist. The exhibition he curated, *The Other Story: Afro-Asian Artists in Post-war Britain*, at the Hayward Gallery in 1989, in which I participated, finally opened the doors of the English art establishment to the many gifted artists from all over the world who had come to live and work in the UK.

My artistic practice takes many forms and continually evolves in response to changes in my life. I was born in Manila during the war, which was almost totally decimated towards the end. Shortly after the war, my brothers and I played in Luneta Park near our home. It was overgrown with tropical vegetation, like a jungle. I loved exploring with my brothers the many bomb-craters that, during the dry season, teemed with butterflies, damselflies and dragonflies. During the rainy season they became breeding grounds for tadpoles, which turned into noisy frogs with the approach of Christmas.

The wild tropical life I knew in the Philippines was in strong contrast to the highly techno-logical and mechanised New York. I became interested in the rela-tionship between nature and the machine, and this interest eventually expressed itself in my first biokinetic sculptures, such as the smoke machine and the bubble machine, the first works of auto-creative art, exhibited in 1964 at the Redfern Gallery in the exhibition *Structures Vivantes: Mobiles / Images*, curated by Paul Keeler – and my first *Sand Machine* of 1964 (the first work of earth art), which was exhibited at Signals London and later at the First Nocturnal Exhibition of Kinetic Art in the Garden of the Villa Foscari 'La Malcontenta', beside the Brenta Canal outside Venice, in 1964.

Apart from the poetry of Walt Whitman and Arthur Rimbaud, I was deeply influenced by two books: *Myths and Symbols of Indian Art and*

Civilisation by Heinrich Zimmer and *Early Ming Wares of Chingtechen* by A.D. Brankston. By the time I co-founded the Exploding Galaxy, a confluence of multi-media artists in London, in 1967, I had become a Buddhist. In the summer and autumn of 1968 I initiated, with American artist John Dugger, a series of participatory dance dramas, *The Buddha Ballet*, on Parliament Hill, London.

During my travels with Dugger throughout Africa and Asia in 1969–70, I became aware of the inequalities and injustices suffered by many people in the world. I became a Marxist and a follower of Mao Zedong's ideas, but always maintained an ironic point of view, an innate scepticism towards all political dogmas. In fact, I resist all dogmas: political, religious, artistic.

When I was still a boy in Manila I read Charles Darwin's *The Voyage of the Beagle*. I think Darwin's theory of evolution instilled in me a love not only of adventure but also of questioning so-called 'received wisdom', i.e. dogma. Another person who inspired me with a sense of adventure was the poet Arthur Rimbaud – I decided to follow his footsteps when I left the Philippines for Europe – and the voyage of Ferdinand Magellan inspired the series of performances that I created with Catalan artist Oriol de Quadras in 1977–9.

In life we always oscillate between two things: necessity and choice. In terms of material needs I go up and down. Sometimes I am fairly well off and sometimes I am definitely poor. I like the fact that sometimes I can go to the Ritz for a nice cup of tea, and at other times I have to scrape and save every penny. The Philippines is prone to many natural disasters: earthquakes, floods, volcanic explosions. We Filipinos have an expression, 'Bahala na!', which, roughly translates as

'Whatever happens!' It means that one is nonchalant and casual with whatever life brings. I have that 'derring-do' sentiment in my DNA. In my artistic practice, I bear in mind this quotation by Walt Whitman: 'Do I contradict myself? Very well then, I contradict myself. I am large. I contain multitudes.'

We are going global whether we like it or not. Economic pressures and technological advances are speeding up globalisation. It first came about in Europe in the Middle Ages, when there were popes and kings, but the real hidden economic powers lay with religious brotherhoods who had monopolies on agricultural products and handicrafts. We are now in another 'Middle Ages', when some nations are still powerful, but even more powerful economically are big corporations, whose interests span many continents. These megacorporations are powerful, not just in the industrial context, but also in the production and distribution of food. Blatant inequalities still exist and changes will have to occur to reduce – perhaps even to eliminate – the inequalities.

The Philippines is a beautiful country of over seven thousand islands. The food, when I was a boy, consisted mainly of local products, such as seafood, native vegetables, fruits and rice. Today, Philippine supermarkets are also full of imported food products. I think, because of our long colonial past (the Philippines, successively, was under Spain, USA and, briefly, Japan), we welcome food products from abroad.

When Ambassador Minda Calaguian-Cruz invited me to participate in the Philippine Art Trek V in Singapore this year (2011), I decided to give a talk on a dessert which 'contained' a delicious

summary of our history. Halo-Halo (literally 'mix-mix') is a dessert composed of different elements such as ubi (a purple root yam, native to the Philippines), leche flan (a cream custard, native to Spain), gulaman (a sea delicacy, found all over Southeast Asia), makapuno (a special kind of creamy coconut), and crushed ice (which Americans introduced to the Philippines).

In Manila, where we were guests of the Ateneo de Manila Art Gallery, Ramon Lerma, the director of the gallery, and his friendly staff, Joel de Leon, Ian Carlo Jaucian and Thea Garing, had a wonderful time introducing Adam Nankervis, co-founder of the Mondrian Fan Club, director of Another Vacant Space in Berlin and founder of the nomadic Museum MAN, to the Halo-Halo, a kind of 'globalised' fruit cocktail that sums up in delicious pieces the history of the Philippines.

Edited text of an interview with Lizzie Carey-Thomas

Notes

MIGRATION IN EARLY MODERN
BRITAIN

1. J. Geipel, *The Europeans:
An Ethnological Survey*, London 1969,
pp.163–4.

2. V.G. Kiernan, 'Britons Old and
New', in C. Holmes (ed.), *Immigrants
and Minorities in British Society*, London
1978, p.23.

3. P.N. Furbank and W.R. Owens
(eds.), *Daniel Defoe: The True-Born
Englishman and Other Writings*, London
1997, pp.35–6.

4. For a fuller inventory see
Kiernan 1978.

5. There is some debate as to
their importance, for an up-to-date
discussion of which see A.L. Murphy,
The Origins of English Financial Markets,
Cambridge 2009, pp.151–2.

6. This case study is described in
N. Goose, 'The Dutch in Colchester
in the 16th and 17th Centuries:
Opposition and Integration',
in R.Vigne and C. Littleton (eds.),
*From Strangers to Citizens: The Integration
of Immigrant Communities in Britain, Ireland
and Colonial America, 1550–1750*, London,
Brighton, and Portland, OR 2001,
pp.88–98.

7. For a discussion of the
economic impact of early modern
settlers see N. Goose, 'Immigrants
and Economic Development in the
Sixteenth and Early Seventeenth
Centuries', in N. Goose and L. Luu
(eds.), *Immigrants in Tudor and Early Stuart
England*, Brighton 2005, pp.136–60.

8. N. Goose, '"Xenophobia" in Early
Modern England: An Epithet Too Far?',
in Goose and Luu 2005, pp.110–35.

9. The restrictive Commonwealth
Immigrants Act of 1962 was one of the
results of this scaremongering: see
P. Fryer, *Staying Power: The History of Black
People in Britain*, London 1984, pp.381–2.

10. K. Hearn, 'Insiders or
Outsiders?: Overseas-born Artists at
the Jacobean Court', in Vigne and
Littleton 2001, pp.117–26.

11. C. Riding, 'Foreign Artists
and Craftsmen and the Introduction
of the Rococo Style in England', in
Vigne and Littleton 2000, pp.133–43.

PORTRAITURE

1. Parts of this essay previously
appeared in K. Hearn, 'Netherlandish
Artists in the Tate Collection', CODART
Courant, no.19, Winter 2009, pp.10–11,
and K. Hearn, 'Migrant Artists in
Britain in the Seventeenth Century',
in *Portraits and People: Art in Seventeenth
Century Ireland*, Crawford Art Gallery,
Cork 2010, pp.14–17.

2. S. Foister, *Holbein and England*,
New Haven and London 2004, p.114.

3. Ibid., pp.111–14.

4. *Dynasties: Painting in Tudor and
Jacobean England 1530–1630*, exh. cat.,
Tate Gallery, London 1995, pp.11–12.

5. K. Hearn, 'Hans Eworth: Traces
of a Biography', in *A Tudor Mystery:
The Allegorical Portrait of Sir John Luttrell*,
exh. cat., Courtauld Galleries, London
1999, pp.6–7; also *Oxford Dictionary of
National Biography* (ODNB) 2004 entry
on Hans Eworth.

6. K. Hearn, 'Insiders or Outsiders?:
Overseas-born Artists at the Jacobean
Court', in Vigne and Littleton 2001,
pp.117–26.

7. K. Hearn, *Marcus Gheeraerts II:
Elizabethan Artist*, London 2002.

8. *Dynasties*, pp.202–30.

9. S. Foister, 'Foreigners at Court:
Holbein, Van Dyck and the Painter-
Stainers Company', in D. Howarth
(ed.), *Art and Patronage at the Caroline Courts*,
New Haven and London 1993, pp.32–50.

10. K. Hearn (ed.), *Van Dyck and Britain*,
exh. cat., Tate Britain, London 2009,
pp.170–203.

11. See ODNB entry on Cornelius
Johnson, 2004; and K. Hearn, 'The
English Career of Cornelius Johnson',
in J. Röding et al. (eds.), *Dutch and
Flemish Artists in Britain 1550–1800*, Leiden
2003, pp.113–29.

12. ODNB 2004 entry on Sir Peter Lely.

NEW GENRES
The author would like to thank
Sander Karst for his assistance.

1. See J. Howarth, *The Steenwyck
Family as Masters of Perspective*, Turnhout
2009.

2. H. Peacham, *The Art of Drawing
with the Pen*, London 1606, p.28

3. See R.P. Townsend, 'Alexander
Keirincx's Royal Commission of 1639–
1640', in J. Röding et al. (eds.), *Dutch
and Flemish Artists in Britain 1550–1800*,
Leiden 2003, pp.137–50.

4. G.M.G. Rubinstein, 'Artists
from the Netherlands in Seventeenth-
Century Britain: An Overview of their
Landscape Work', in S. Groen and
M. Wintle (eds.), *The Exchange of Ideas,
Religion, Scholarship and Art in Anglo-
Dutch Relations in the Seventeenth Century*,
Zutphen 1994.

5. K. Hearn, 'Merchant Clients
for the Painter Jan Siberechts',
in Röding et al. 2003, pp.83–92.

6. P. Bagni, *Benedetto Gennari
e la Bottega del Guercino*, Padua 1986.

7. See C. Brett, 'Antonio Verrio
(c.1636–1707): His Career and Surviving
Work', and B. Dolman, 'Antonio
Verrio (c.1636–7) and the Royal Image
at Hampton Court', *British Art Journal*,
vol.10, no.3, Winter/Spring 2009/10,
pp.4–17 and 18–28.

8. ODNB entry by D. Cordingley,
2004.

9. ODNB entry by D. Brooks, 2004.

10. L.B. Shaw, 'Pieter van
Roestraeten and the English "Vanitas"',
Burlington Magazine, vol.132, no.1047,
June 1990, pp.402–6.

11. On Collier, see D. Pring,
'The Negotiation of Meaning in the
Musical Vanitas and Still-life Paintings
of Edwaert Collier (c.1640–1709)', PhD
thesis, Goldsmiths College, University
of London, April 2010.

12. ODNB entry on Le Sueur by C.
Avery, 2004; ODNB entry on Francesco
Fanelli by S.Stock, 2004.

ITALY, NEOCLASSICISM AND THE
ROYAL ACADEMY

1. See A. Wilton and I. Bignamini
(eds.), Grand Tour: The Lure of Italy in the
Eighteenth Century, exh. cat., Tate Gallery,
London 1996.

2. See D. Irwin, Neoclassicism,
London 1997.

3. See C. Beddington (ed.), Canaletto
in England: A Venetian Artist Abroad, exh.
cat., Yale Center for British Art, New
Haven 2006.

4. H. von Erffa and A. Staley,
The Paintings of Benjamin West, New Haven
and London, 1986.

5. S. West, 'Francesco Zuccarelli',
in Grove Art Online.

6. E. Waterhouse, Painting in Britain
1530–1790 (1953), New Haven and
London 1994, pp.232–40.

7. D. Graham-Vernon, 'Nathanial
Dance', in Oxford Dictionary of National
Biography.

8. T.G. Natter (ed.), Angelica
Kauffman: A Woman of Immense Talent, exh.
cat., Vorarlberger Landesmuseum,
Bregenz 2007.

9. For the history of its founda-
tion and full details of membership see
S. Hutchinson, The History of the Royal
Academy 1768–1968, London 1968.

10. See S. West, 'Xenophobia and
Xenomania: Italians and the English
Royal Academy', in S. West (ed.), Italian
Culture in Northern Europe in the Eighteenth
Century, Cambridge 1999, pp.116–39.

11. For comment and full tran-
script see F.W. Hilles, The Literary Career
of Sir Joshua Reynolds, Cambridge 1936,
pp.174–6, 249–76.

DIALOGUES BETWEEN BRITAIN,
FRANCE AND AMERICA

1. See K. Adler, '"We'll Always Have
Paris": Paris as Training Ground and
Proving Ground', in Americans in Paris
1860–1900, exh. cat., National Gallery,
London 2006, pp.27–46.

2. See P. Gillett, 'Art Publics in
Late Victorian England', in Worlds of Art,
New Jersey 1990, pp.192–241 and
E. Morris, French Art in Nineteenth-century

Britain, New Haven and London 2005,
pp.130–6, 140–51.

3. K. Lochnan, The Etchings of James
McNeill Whistler, New Haven and London
1984, pp.21–3.

4. Lochnan 1984, pp.48–9, 67–8.

5. See R. Dorment and M.F.
MacDonald (eds.), James McNeill Whistler,
exh. cat., Tate Gallery, London 1995,
pp.71–2.

6. See R. Dorment, 'The Six
Projects', in Dorment and MacDonald
1995, pp.93–4, and A.M. Young, The
Paintings of James McNeill Whistler, New
Haven and London 1980, pp.52–3.

7. M. Geiger, 'La Peinture
d'Alphonse Legros en Angleterre', in
Memoires de l'Académie des Sciences, Arts et
Belle-Lettres de Dijon, vol.112, 1958, p.76,
Lochnan 1984, pp.128–30 and Morris
2005, pp.262–3.

8. See Morris 2005, pp.137–8,
263–4 and Geiger 1958, p.76.

9. S. MacDonald, The History and
Philosophy of Art Education, London 1970,
pp.270–5.

10. Geiger 1958, p.81.

11. Morris 2005, pp.154–60.

12. M. Wentworth, James Tissot,
Oxford 1984, pp.78–83.

13. Ibid., pp.84–8.

14. Ibid., pp.90–4.

15. See N.R. Marshall, 'Image
or Identity: Kathleen Newton and
the London Pictures of James Tissot',
pp.28–31, and T. Garb, 'Painting
the Parisienne: James Tissot and the
Making of the Modern Woman',
in K. Lochnan (ed.), Seductive Surfaces:
The Art of Tissot, New Haven and London
1999, p.103.

16. See Wentworth 1995, pp.278–83
and Marshall 1999, pp.31–41.

17. Wentworth 1995, pp.115, 127–8.

18. See R. Ormond and E. Kilmurray,
John Singer Sargent: Complete Paintings,
vol.1, The Early Portraits, New Haven and
London 1998, no.114, pp.113–15.

19. Morris 2005, p.276.

20. See T. Endelman, The Jews of Britain
1656–2000, Berkeley and London 2002,
pp.91–100, and K. Adler, 'Sargent's

Portraits of the Wertheimer Family',
in T. Garb and L. Nochlin (eds.), The
Jew in the Text: Modernity and the Construction
of Identity, London 1995, p.85.

21. R. Ormond and E. Kilmurray,
John Singer Sargent: Complete Paintings,
vol.3: The Later Portraits, New Haven
and London 1998, p.55.

22. See Adler 1995, pp. 91–4,
and E. Prettejohn, Interpreting Sargent,
London 1998, pp.41–2.

23. Prettejohn 1998, p.47.

MIGRATION TO BRITAIN
SINCE 1800

1. For further reading on
the topics raised in this essay, see:

Anthias, F., Ethnicity, Class,
Gender and Migration: Greek Cypriots in
Britain, Aldershot 1992.

Ballard, R. (ed.), Desh Pradesh:
The South Asian Presence in Britain,
London 1994.

Cohen, R., Frontiers of Identity:
The British and the Others, London 1994.

Endelman, Todd M., The Jews
of Britain, 1656–2000, Los Angeles
and Berkerley 2002.

Gilroy, P. There Ain't No Black
in the Union Jack': The Cultural Politics
of Race and Nation, London 1987.

Holmes, C., John Bull's Island:
Immigration and British Society, 1871–1971,
Basingstoke 1988.

Kushner, T. and Knox, K.,
Refugees in an Age of Genocide: Global,
National and Local Perspectives during
the Twentieth Century, London 1999.

MacRaild, D.M., Irish Migrants
in Modern Britain, 1750–1922,
Basingstoke 1999.

Modood, T. and Berthoud, R.,
et. al. (eds.), Ethnic Minorities in Britain:
Diversity and Disadvantage, London 1997.

Panayi, P. (ed.), Germans in
Britain since 1500, London 1996.

Panayi, P., An Immigration
History of Britain: Multicultural Racism
since c1800, London 2010.

Panayi, P., Spicing Up Britain:
The Multicultural History of British Food,
London 2008.

Solomos, J., *Race and Racism in Modern Britain*, Basingstoke 1993.

Watson, J. L. (ed.), *Between Two Cultures: Migrants and Minorities in Britain*, Oxford 1977.

JEWISH ARTISTS AND JEWISH ART IN LONDON

1. S.J. Solomon, 'Art and Judaism', *Jewish Quarterly Review*, vol.13, July 1901, p.553. Solomon argued that there was no identifiable Jewish art due to the lack of a tradition of representation of the human form in Judaism. There has been extensive debate about how to define Jewish art ever since. Key issues are whether the artist's origins, the choice of subject matter or a particular style might constitute a distinctively Jewish art. See M. Bohm-Duchen, 'Jewish Art or Jewish Artists: A Problem of Definition', in W. Schwab and J. Weiner (eds.), *Jewish Artists: The Ben Uri Collection*, London 1994, pp.12–15, for a succinct summary of the issues.

2. See T. Endelman, *The Jews of Britain 1656–2000*, Berkeley and London 2002, pp.127–37.

3. See D. Feldman, 'The Importance of Being English: Jewish Immigration and the Decay of Liberal England', in D. Feldman and G. Stedman-Jones (eds.), *Metropolis-London: Histories and Representations since 1800*, London 1987.

4. Feldman 1987, pp.63–5. He argues that the Aliens Act of 1905 contributed to a definition of the idea of Englishness at this period, as well as being a practical legal initiative.

5. W. Rothenstein, *Men and Memories*, vol.1, London 1932, pp.35–6.

6. See *Exhibition of Jewish Art and Antiquities*, exh. cat., Whitechapel Art Gallery, London 1906.

7. See J. Steyn, 'The Complexities of Assimilation in the 1906 Whitechapel Art Gallery exhibition "Jewish Art and Antiquities"', *Oxford Art Journal*, vol.13, no.2, 1990, pp.44–50; and L. Tickner, 'David Bomberg: *In the Hold*, Jews and Cubism', in *Modern Life and Modern Subjects: British Art in the Early Twentieth Century*, New Haven and London 2000, pp.154–5.

8. See *Exhibition of Jewish Art and Antiquities* 1906, and Tickner 2002, pp.154–5, 165.

9. See J. Wolff, 'The Failure of a Hard Sponge: Class, Ethnicity and the Art of Mark Gertler', in *New Formations*, no.28, Spring 1996.

10. J. Steyn 'Mythical Edges of Assimilation: An Essay on the Early Works of Mark Gertler, in *Mark Gertler: Paintings and Drawings*, exh. cat., Camden Arts Centre, London 1992, pp.11–13.

11. See T. Garb, 'Modernity, Identity, Textuality', in L. Nochlin and T. Garb (eds.), *The Jew in the Text: Modernity and the Construction of Identity*, London 1995, pp.22–4, on the construction of Jewish identity in modern society in which the Jew was seen to embody 'atavistic, animalistic and affective qualities' in contrast to the 'rationalism and control' of post-Enlightenment society.

12. See A. Greutzner Robins, *Modern Art in Britain*, exh. cat., Barbican Art Gallery, London 1997, pp.139–58, for an overview of the exhibition.

13. Lisa Tickner argues the former, see Tickner 2002, pp.154–63; Juliet Steyn argues the latter, see 'Inside-out: Assumptions of "English" Modernism in the Whitechapel Art Gallery, London 1914', in M. Pointon (ed.), *Art Apart: Art Institutions and Ideology Across England and North America*, Manchester and New York 1994, pp.225–8.

14. R. Cork, *David Bomberg*, New Haven and London 1987, p.47.

15. See Tickner 2002, p.219.

16. 'A Jewish Futurist: Chat with Mr David Bomberg', *Jewish Chronicle*, 8 May 1914, p.13.

17. Tickner 2002, p.297, no.158.

18. See Steyn 1994, pp.222–5, 228, Woolf 1996, p.63 and Tickner 2002, pp.160–2.

19. 'Jewish Art at Whitechapel: Twentieth Century Exhibition', *Jewish Chronicle*, 15 May 1914, p.10.

20. A.J. Finberg in the *Star*, 20 May 1914, quoted in Steyn 1992, pp.17–18.

21. Steyn 1992, p.17 and Tickner 2002, pp.166–71.

22. Quoted in Cork 1987, p.78.

23. Cork 1987, p.86.

REFUGEES FROM NAZI EUROPE

1. See J. Vinzent, *Identity and Image: Refugee Artists from Nazi Germany in Britain (1933–1945)*, Weimar 2006, pp.23–31, 73–9; and S. Barron, 'European Artists in Exile: A Reading Between the Lines', in Barron (ed.), *Exiles and Émigrés: The Flight of European Artists from Hitler*, exh. cat., Los Angeles County Museum of Art 1997, pp.11–29.

2. See S. Barron, 'Modern Art and Politics in Prewar Germany', in Barron (ed.), *'Degenerate Art': The Fate of the Avant-garde in Nazi Germany*, exh. cat., Los Angeles County Museum of Art 1991, pp.9–23.

3. See H. Read, 'A Nest of Gentle Artists', *Apollo*, Sept. 1962, repr. B. Read and D. Thistlewood (eds.), *Herbert Read: A British Vision of World Art*, Leeds 1993.

4. See Vinzent 2006, pp.35–40; and R. Dickson and S. MacDougall, 'Artists in Exile in Britain c.1933–45', in *Forced Journeys: Artists in Exile in Britain c.1933–1945*, exh. cat., Ben Uri Art Gallery, London 2009, p.35.

5. R. Kinross, 'Émigré Graphic Designers in Britain: Around the Second World War and Afterwards', *Journal of Design History*, vol.3, no.1, 1990, pp.35–6.

6. See T. Senter, 'Moholy-Nagy: The Transitional Years', in A. Borchardt-Hume (ed.), *Albers and Moholy-Nagy: From the Bauhaus to the New World*, exh. cat., Tate Modern, London 2006, p.86; and Moholy-Nagy to Ben Nicholson, letters from May to October 1934, Tate Gallery Archive (TGA), TGA 8717/1/2/2/2973–2977.

7. Senter 2006, pp.88–9.

8. Ibid., pp.87–8.

9. M. Hammer and C. Lodder, *Constructing Modernity: The Art and Career of Naum Gabo*, New Haven and London 2000, pp.221–6.

10. Ibid., pp.235, 244.

11. Ibid., p.233.

12. Ibid., p.242.

13. Ibid., pp.253–4, 287–290.

14. Ibid., pp.292–7.

15. Mondrian to Nicholson, 1934–8, TGA 8717/1/2/2984–3008.

16. M. Seuphor, *Piet Mondrian: Life and Work*, London 1957, p.171; and J. Milner, *Mondrian*, London 1992, p.200.

17. Mondrian to Nicholson, 17 Feb. 1940, TGA 8717/1/2/3013.

18. Seuphor 1957, p.187; and Milner 1992, pp.206–7.

19. Mondrian to John Cecil Stephenson, Oct. 1940, TGA 200324/13.

20. See K. Holz, *Modern German Art for Paris, Prague and London*, Ann Arbor 2004, pp.195–22, 234–6.

21. Vinzent 2006, pp.30–3.

22. See ibid., pp.45–6.

23. R. Calvocoressi, *Oskar Kokoschka*, exh. cat., Tate Gallery, London 1986, pp.150–1. See also ibid., pp.40–1.

24. Quoted in Calvocoressi 1986, p.320.

25. Barron 1991, p.194.

26. Ibid., p.196.

27. Hammer and Lodder 2000, p.248.

28. I. Schlenker, *Marie Louise von Motesiczky 1906–1996: A Catalogue Raisonné of the Paintings*, Manchester and New York 2009, p.143.

29. Vinzent 2006, pp.57–8.

THE STATELESS ARTIST

1. Interview with Lynda Morris, December 1972 in H. Ander, A. Bangma and B. van Kooij (eds.), *David Lamelas: A New Refutation of Time*, exh. cat., Kunstverein München, Düsseldorf 1997, p.14.

2. G. Brett, *Exploding Galaxies: The Art of David Medalla*, London 1995, p.14.

3. David Medalla, 'Some Reflections on the Random in Life and Art', unpublished text, Rotterdam 1985, in Brett 1995, p.19.

4. Gustav Metzger, unpublished text written for *Quadrum*, in Brett 1995, p.55.

MOBILITY IN CONTEMPORARY ART

1. E. Said, 'The Art of Displacement: Mona Hatoum's Logic of Irreconcilables', in *Mona Hatoum: The Entire World as a Foreign Land*, exh. cat., Tate Gallery, London 2000, p.17.

2. K. Mercer, 'Diaspora Culture and the Dialogic Imagination: The Aesthetics of Black Independent Film in Britain', in *Welcome to the Jungle: New Positions in Black Cultural Studies*, London 1994, pp.253–4.

3. See F. Fanon, *The Wretched of the Earth*, trans. C. Farrington, London 2001.

4. Mercer 1994, p.62.

5. H. Bhabha, 'Dissemination: Time Narrative and the Margins of the Modern Nation', in *Nation and Narration*, London 1990; see also H. Bhabha, *The Location of Culture*, London 1994.

6. For an important critique of the YBA phenomenon, see K. Mercer, 'Ethnicity and Internationality: New British Art and Diaspora-Based Blackness', *Third Text*, no.49, Winter 1999–2000, pp.15–26.

7. On the 'race industry' see C. Mohanty, 'On Race and Voice: Challenges for Liberal Education in the 1990s', *Cultural Critique*, no.2, 1990.

8. S. Žižek, 'Multiculturalism, Or, the Cultural Logic of Multinational Capitalism', in *The Universal Exception*, London 2006, pp.151–82. See also Hardt and Negri in *Empire*, who query: 'What if a new paradigm of power, a postmodern sovereignty, has come to replace the modern paradigm and rule through differential hierarchies of the hybrid and fragmentary subjectivities that these [postcolonial] theorists celebrate? In this case, modern forms of sovereignty would no longer be at issue, and the postmodernist and postcolonialist strategies that appear to be liberatory would not challenge but in fact coincide with and even unwittingly reinforce the new strategies of rule!' M. Hardt and A. Negri, *Empire*, Boston 2000, p.138.

9. P. Gilroy, *Against Race: Imagining Political Culture Beyond the Color Line*, Cambridge, MA 2000; see also E. Hobsbawm, 'Identity Politics and the Left', *New Left Review*, May/June 1996; and on the question of post-black aesthetics in the US, see D. English, *How To See a Work of Art in Total Darkness*, Cambridge, MA 2007.

10. See 'Paul Gilroy Speaks on the Riots, Tottenham, North London, 16 Aug. 2011', the Dreams of Safety Blogspot, at: http://dreamofsafety. blogspot.com/2011/08/paul-gilroy-speaks-on-riots-august-2011.html

11. For instance, in M. Reilly (ed.), *Global Feminisms: New Directions in Contemporary Art*, London 2007. See also S. Maharaj (ed.), *Farewell to Post-Colonialism: Querying the Guangzhou Triennial 2008*, exh. cat., Visual Artists Ireland, Dublin 2009.

12. J.-P. Criqui, 'Like a Rolling Stone: Gabriel Orozco', *Artforum*, April 1996.

13. Said 1984, p.159.

14. Hardt and Negri 2000, pp.360–1.

15. For further consideration of this development, see M. Kwon, 'One Place After Another: Notes on Site Specificity', *October*, no.80, Spring 1997.

16. A. B. Oliva, 'The Globalisation of Art', in K. Boullata (ed.), *Belonging and Globalisation: Critical Essays in Contemporary Art and Culture*, London 2008, pp.43–4.

17. Spivak proposed 'a strategic use of positivist essentialism in a scrupulously visible political interest' – yet not without a controversial reception. See D. Landry and G. Maclean (eds.), *The Spivak Reader: Selected Works of Gayatri Chakravorty Spivak*, New York 1996, p.214.

18. J. Meyer, 'Nomads', *Parket*, no.35, May 1997, p.207. Meyer differentiates 'lyrical nomads' (such as Tiravanija and Orozco), who practice 'a mobility thematized as a random and poetic interaction with the objects and spaces of everyday life', from 'critical nomads' (including Andrea Fraser, Christian Philipp Müller,

Renee Green and Mark Dion), designating those who work out of the tradition of institutional critique. The latter model 'does not so much enact and record a discrete action or movement as locate the structures of mobility within specific historical, geographical, and institutional frameworks' (p.206). See also Kwon 1997, p.104, who points out that nomadism's 'hermetic implosion of (auto) biographical and subjectivist indulgences' may be 'misrepresented as self-reflexivity'.

19. Exemplary is Rirkrit Tiravanija, *A Retrospective (Tomorrow Is Another Fine Day)* in 2005 at Musée d'Art Moderne de la Ville de Paris/arc at the Couvent des Cordeliers, Paris.

20. See J. Huysmans, *The Politics of Insecurity: Fear, Migration and Asylum in the EU*, London 2006 and J. Tirman (ed.), *The Maze of Fear: Security and Migration after 9/11*, London 2004.

21. Müller exemplifies one of Meyer's 'critical nomads'. See also G. Baker, 'Lies, Damn Lies, and Statistics: The Art of Christian Philipp Müller', *Artforum*, Feb. 1997, pp.74–7, 109.

22. See A. Bensaâd, 'The Militarization of Migration Frontiers in the Mediterranean', in U. Biemann and B. Holmes (eds.), *The Maghreb Connection: Movements of Life Across North Africa*, Barcelona 2006. Also see T.J. Demos, 'Europe of the Camps', in A. Budak, N. Möntmann et al. (eds.), *Manifesta 7: Companion: The European Biennial of Contemporary Art*, Milan 2008.

23. See www.migreurop.org. See also C. Rodier, 'The Migreurop Network and Europe's Foreigner Camps', in M. Feher et al. (eds.), *Non-Governmental Politics*, New York 2007.

24. Hardt and Negri 2000, p.361.

25. It also suggests a logic whereby the excluded are necessary to the self-constitution of the nomad's position of freedom – which is similar to the mutually constitutive logic of minority and majority, and subaltern and hegemon, as theorised in H. Bhabha, 'Unsatisfied: Notes on Vernacular Cosmopolitanism', in L. Garcia-Moreno and P.C. Pfeiffer (eds.), *Text and Nation: Cross-Disciplinary Essays on Cultural and National Identities*, Columbia, SC 1996, pp.191–207.

26. Said 1993, pp.116, 119; Agamben 1993, p.25.

27. Said 2000, p.17: 'Better disparity and dislocation than reconciliation under duress of subject and object; better a lucid exile than sloppy, sentimental homecomings; better the logic of dissociation than an assembly of compliant dunce. A belligerent intelligence is always to be preferred over what conformity offers, no matter how unfriendly the circumstances and unfavourable the outcome.' Not surprisingly, before his death Said came to favour a bi-national – and distinctly anti-nationalist – solution to the Israeli-Palestinian conflict. See E. Said, 'The One-State Solution', *New York Times*, 10 Jan. 1999.

28. O. Enwezor, 'Mega-Exhibitions and the Antinomies of a Transnational Global Form', MJ – *Manifesta Journal*, no.2, Winter 2003/Spring 2004, pp.6–31.

29. Columbia University's Center for International Earth Science Information Network projects that 700 million climate refugees will be on the move by 2050. See K. Warner et al., 'In Search of Shelter: Mapping the Effects of Climate Change on Human Migration and Displacement', Earth Institute of Columbia University, May 2009, http://ciesin.columbia.edu/documents/clim-migr-report-june09—media.pdf. Also see C. Parenti, *Tropics of Chaos: Climate Change and the New Geography of Violence*, New York 2011.

NEW DIASPORIC VOICES

1. Middle Passage refers to the forced transportation of millions of African slaves in slave ships from African coasts to the New World of North America, Latin America and the Carribean from the fifteenth to the eighteenth centuries.

2. Rasheed Araeen included Hatoum in his seminal survey of 'black art' in 1988, *The Essential Black Art* (Chisenhale Gallery, London, and touring). However in a later interview with Michael Archer Hatoum downplayed the link between her practice at this time and 'black art'. See Michael Archer Interview with Mona Hatoum, in M. Archer, G. Brett and C. de Zegher, *Mona Hatoum*, London 1997, p.14.

3. J. Roberts, 'Postmodernism and the Critique of Ethnicity: The Recent Work of Rasheed Araeen', in *From Modernism to Postmodernism: Rasheed Araeen. A Retrospective 1959-1987*, exh. cat., Ikon Gallery, London 1987.

THE MOVING IMAGE

1. W.J.T. Mitchell, *What Do Pictures Want?: The Lives and Loves of Images*, Chicago and London 2005, p.85.

2. M. Lind and H. Steyerl (eds.), *The Green Room: Reconsidering the Documentary and Contemporary Art* no.1, Berlin 2008, p.16.

3. Hito Steyerl, 'The Uncertainty of Documentarism', Chto Delat/What Is To Be Done?' www.chtodelat.org.

4. Rosalind Nashashibi, quoted in M. Jeffrey, 'The Rhythm of Life, *Herald Scotland*, 17 April 2004.

5. Zineb Sedira, quoted in press release, 14 April 2009, www.iniva.org/press/2009/

6. D. Leader, unpublished text.

7. See M. Godfrey, 'Poetics/Politics: The Work of Francis Alÿs' in *Francis Alÿs: A Story of Deception*, exh. cat., Tate Modern, London 2010, p.21.

List of Illustrated Works

All works are in the Tate collection except those marked with an asterisk

Jankel Adler, *The Mutilated* 1942–3. Presented by Robert Strauss 1960 [fig.37]

Francis Alÿs, *Paradox of Praxis 1 (Sometimes Doing Something Leads to Nothing)*, Mexico City 1997. Courtesy the artist* [fig.52]

Francis Alÿs, *Railings* 2004. Presented by Tate Patrons 2006 [fig.59]

Rasheed Araeen, *Rang Baranga* 1969. Presented by Tate Members 2007 [fig.47]

Rasheed Araeen, *Bismullah* 1988. Purchased 1995 [fig.54]

Black Audio Film Collective (John Akomfrah; Reece Auguis; Edward George; Lina Gopaul; Avril Johnson; David Lawson; Trevor Mathison) *Handsworth Songs* 1986. Presented by Tate Members 2008 [fig.53]

David Bomberg, *The Mud Bath* 1914. Purchased 1964 [fig.34]

Frank Bowling, *Who's Afraid of Barney Newman* 1968. Presented by Rachel Scott 2006 [fig.45]

Sonia Boyce, *From Tarzan to Rambo: English Born 'Native' Considers her Relationship to the Constructed/Self Image and her Roots in Reconstruction* 1987. Purchased 1987 [fig.56]

Canaletto, *London: The Old Horse Guards from St Jame's Park* c.1749. Lent by the Andrew Lloyd Webber Foundation 2000* [fig.15]

Agostino Carlini, *Bust of George III* 1773. Royal Academy of Arts, London* [fig.20]

Avinash Chandra, *Hills of Gold* 1964.

Presented by Dr Gerhard and Hella Adler 1965 [fig.43]

Nathaniel Dance-Holland, *The Meeting of Dido and Aeneas* exh.1766. Purchased with assistance from the Art Fund 1993 [fig.18]

Jacob Epstein, *Euphemia Lamb* 1908. Presented by the Contemporary Art Society 1917 [fig.33]

Hans Eworth, *Portrait of an Unknown Lady* c.1565–8. Purchased with assistance from the Friends of the Tate Gallery 1984 [fig.4]

Hans Feibusch, *1939* 1939 Purchased 1996 [fig.41]

Mark Gertler, *The Artist's Mother* 1911. Presented by the Trustees of the Chantrey Bequest 1944 [fig.31]

Mark Gertler, *Jewish Family* 1913. Bequeathed by Sir Edward Marsh through the Contemporary Art Society 1954 [fig.32]

Marcus Gheeraerts II, *Portrait of Mary Rogers, Lady Harington* 1592. Purchased with assistance from the Art Fund and subscribers 1974 [fig.5]

Marcus Gheeraerts II, *Portrait of Captain Thomas Lee* 1594. Purchased with assistance from the Friends of the Tate Gallery, the Art Fund and the Pilgrim Trust 1980 [fig.1]

Mona Hatoum, *Measures of Distance* 1988. Purchased 1999 [fig.55]

William Hogarth, *The Strode Family* c.1738. Bequeathed by Rev. William Finch 1880 [fig.2]

Hans Holbein the Younger c.1497–1543, *Henry VIII* c.1537. Museo Thyssen-Bornemisza, Madrid* [fig.3]

Isaac Julien, *Territories* 1984.

Courtesy Isaac Julien and Victoria Miro Gallery, London* [fig.51]

Angelica Kauffmann, *Portrait of a Lady* c.1775. Presented by Mrs M. Bernard 1967 [fig.19]

Alexander Keirincx *Distant View of York* 1639. Purchased 1986 [fig.10]

Godfrey Kneller, *Portrait of John Banckes* 1676. Purchased with assistance from the Friends of the Tate Gallery 1987 [fig.9]

Oskar Kokoschka, *The Crab* 1939–40. Purchased 1984 [fig.38]

David Lamelas, *A Study of Relationships Between Inner and Outer Space* 1969. Courtesy David Lamelas and LUX, London* [fig.49]

Peter Lely, *Susanna and the Elders* c.1650–5. Presented by the Friends of the Tate Gallery 1961 [fig.14]

Steve McQueen, *Static* 2009. Purchased 2011 with assistance from Ivor Braka, Thomas Dane, Mrs Wendy Fisher and Zamyn [fig.58]

David Medalla, *Cloud Canyons* 1961. Photographs by Clay Perry c.1964, courtesy England & Co., London* [fig.50]

Gustav Metzger demonstrating his *Auto-Destructive Art* at the South Bank, London, 3 July 1961 [fig.48]

Piet Mondrian, *Composition with Yellow, Blue and Red* 1937–42. Purchased 1964 [fig.36]

Rosalind Nashashibi, *Hreash House* 2004. Presented by Tate Members 2006 [fig.60]

Peter Peri, *Mr Collins from the A.R.P.* 1940. Purchased 1988 [fig.39]

Keith Piper, *Go West Young Man* 1987.
Purchased 2008
[illus. p.3]
Donald Rodney, *In the House of My Father*
1996–7. Presented by the Patrons
of New Art (Special Purchase Fund)
2001
[fig.57]
William Rothenstein, *Mother and Child*
1903. Purchased 1988
[fig.29]
William Rothenstein, *Jews Mourning in a
Synagogue* 1906. Presented by Jacob
Moser J.P. through the Trustees
and Committee of the Whitechapel
Art Gallery in commemoration
of the 1906 Jewish Exhibition 1907
[fig.30]
John Singer Sargent, *Study of Mme
Gautreau* c.1884. Presented by Lord
Duveen through the Art Fund 1925
[fig.25]
John Singer Sargent, *Ena and Betty,
Daughters of Asher and Mrs Wertheimer*
1901. Presented by the widow and
family of Asher Wertheimer in
accordance with his wishes 1922
[fig.26]
Kurt Schwitters, *Picture of Spatial Growths
– Picture with Two Small Dogs* 1920–39.
Purchased 1984
[fig.35]
Zineb Sedira, *Floating Coffins* 2009.
Purchased 2011
[fig.61]
Anwar Jalal Shemza, *Chessmen One* 1961.
Purchased 2010
[fig.44]
Jan Siberechts, *View of a House and
its Estate in Belsize, Middlesex* 1696.
Purchased with assistance from
the Art Fund and the Friends of
the Tate Gallery 1995
[fig.11]
F.N. Souza, *Crucifixion* 1959. Purchased
1993
[fig.42]
James Tissot, *The Gallery of HMS Calcutta
(Portsmouth)* c.1876. Presented by
Samuel Courtauld 1936
[fig.24]

Willem van de Velde the Younger,
*The Departure of William of Orange and
Princess Mary for Holland, November 1677*
1677. National Maritime Museum,
London*
[fig.12]
Anthony van Dyck, *Henrietta Maria* 1636.
The Trustees of Chequers Trust*
[fig.6]
Anthony van Dyck, *Charles I* 1636
The Trustees of Chequers Trust*
[fig.7]
Antonio Verrio, *Sketch for a Ceiling
Decoration: An Assembly of the Gods*
c.1680–1700. Purchased 1967
[fig.13]
Marie-Louise von Motesiczky
Still Life with Sheep 1938.
Purchased 1986
[fig.40]
Benjamin West, *Pylades and Orestes
Brought as Victims before Iphigenia* 1766.
Presented by Sir George Beaumont
Bt 1826
[fig.16]
James Abbott McNeill Whistler
Three Figures: Pink and Grey 1868–78.
Purchased with the aid of contri-
butions from the International
Society of Sculptors, Painters and
Gravers as a Memorial to Whistler,
and from Francis Howard 1950
[fig.21]
James Abbott McNeill Whistler
*Nocturne: Blue and Silver – Cremorne
Lights* 1872. Bequeathed by
Arthur Studd 1919
[fig.22]
James Abbott McNeill Whistler
Miss Agnes Mary Alexander c.1873.
Bequeathed by W.C. Alexander 1950
[fig.23]
Aubrey Williams, *Death and the
Conquistador* 1959. Purchased 2011
[fig.46]
Willem Wissing, *Portrait of Henrietta and
Mary Hyde* c.1683–5. Purchased 2006
[fig.8]
Francesco Zuccarelli, *A Landscape with
the Story of Cadmus Killing the Dragon*
exh.1765. Purchased 1985
[fig.17]

Index

Acknowledgements

The authors are grateful to: John Akomfrah, Jake Astbury, Andrew Lloyd Webber Foundation, Tabitha Barber, Hans Biorn Lian, Leona Bowman, David Bownes, Sonia Boyce, Eddie Chambers, Rachel Crome, Richard Crowther, Laurie Endean, Kodwo Eshun, Aleda Fitzpatrick, Bronwyn Gardner, Andreas Gegner, Nigel Goose, Tim Green, Rebecca Hellen, Kate Jennings, Sander Karst, Anne Kershen, Kim Knott, David Lawson, Hannah Liley, Teresa Lima, Nigel Llewellyn, Sarah MacDougall, Roanne Marner, David Medalla, Rodney Melville, Sarah Miller, John Morgan, Edwina Mulvaney, Martin Myrone, Sally O'Reilly, Miriam Perez, Keith Piper, Judith Severne, Rachel Silman, Ronald Skeldon, Alison Smith, Gates Sofer, Alia Syed, Wolfgang Tillmans, Piers Townshend, Marjorie Trusted, Helen Valentine, Natasha Walker, Ian Warrell, David Wilson.

The exhibition at Tate Britain has been made possible by the provision of insurance through the Government Indemnity Scheme. Tate Britain would like to thank HM Government for providing Government indemnity and the Department for Culture, Media and Sport and the Museums, Libraries and Archives Council for arranging the indemnity.

Lenders

The Andrew Lloyd Webber Foundation
The Chequers Estate
Contemporary Films Ltd, London
Richard Crowther Antiques
England & Co., London
London Transport Museum, London
LUX, London
National Maritime Museum, Greenwich, London
Private collection. Courtesy Richard Green Gallery, London
Royal Academy of Arts, London

Photo Credits

All images Tate Photography except for the following (references are to figures):

Courtesy the artist and Galerie Kamel Mennour, Paris 61
Photo: Thierry Bal 59
By kind permission of the Chequers Trust 6, 7
Courtesy Thomas Dane Gallery, London and Marian Goodman Gallery, New York and Paris 58
Photo: Enrique Huerta 52

Courtesy Isaac Julien and Victoria Miro Gallery 51
Photo: Keystone/Hulton Archive/Getty Images 48
Courtesy David Lamelas and LUX, London 49
London Metropolitan Archives 27
©Museo Thyssen-Bornemisza, Madrid 3
©National Maritime Museum, Greenwich, London 12
Photo: Panikos Panayi 28
©Clay Perry, courtesy England & Co., London 50
Royal Academy of Arts, London. Photo: Paul Highnam 20
Smoking Dogs Films 53
Tate Photography/Gabrielle Fonseca Johnson 4
Tate Photography/Mark Heathcote 43, 46

Copyright credits

First published 2012 by order of the Tate Trustees
by Tate Publishing, a division of Tate Enterprises Ltd,
Millbank, London SW1P 4RG
www.tate.org.uk/publishing

on the occasion of the exhibition
Migrations: Journeys into British Art
Tate Britain
31 January–12 August 2012

A catalogue record for this book is available from
the British Library

ISBN 978 1 84976 007 2

Designed by John Morgan
assisted by Teresa Lima, John Morgan studio
Colour reproduction by Alta Image, London
Printed in Italy by Mondadori Printing, Verona

Cover: Marbling designed by Payhembury Marbled Papers,
Cambridge ©Tate 2012
Page 3: Keith Piper (born 1960) *Go West Young Man* 1987
Photograph on paper mounted on board

Measurements of artworks are given in centimetres,
height before width. Works are from the Tate collection
unless otherwise stated.

Contributors

Lizzie Carey-Thomas is Curator, Contemporary British Art,
Tate Britain

John Akomfrah (born 1957, Accra, Ghana) is a filmmaker
living and working in London, and was co-founder
of the Black Audio Film Collective (1982–1998)

Tim Batchelor is Assistant Curator, Tate Britain

Sonia Boyce MBE (born 1962, London) is an artist living
and working in London

Emma Chambers is Curator, Modern British Art,
Tate Britain

T.J. Demos is a writer and critic, and Reader in Modern
and Contemporary Art at University College London

Kodwo Eshun (born 1966, London) is an artist, curator and
writer living and working in London. He co-founded
The Otolith Group with Anjalika Sagar in 2001

Leyla Fakhr is Assistant Curator, Tate Britain

Paul Goodwin is an independent curator based in London,
and formerly Curator of Cross Cultural Programmes at
Tate Britain

Nigel Goose is Professor of Social and Economic History
and Director of the Centre for Regional and Local
History at the University of Herefordshire

Karen Hearn is Curator, Sixteenth- and Seventeenth-
Century British Art, Tate Britain

David Medalla (born 1942, Manila, Philippines) is an artist
living and working in London

Lena Mohamed is Curatorial Assistant, Tate Britain

Panikos Panayi is Professor of European History at
De Montfort University, Leicester

Wolfgang Tillmans (born 1968, Remscheid, Germany)
is an artist living and working in London and Berlin